In All Directions **Travel and Illustration**

Selected by Quentin Blake

National Touring Exhibitions
Hayward Gallery
South Bank Centre, London

Published on the occasion of *In All Directions*, a National Touring Exhibition organised by the Hayward Gallery, London, for Arts Council England

Exhibition selected by Quentin Blake
Exhibition conceived in collaboration with:

Exhibition tour:

9 July – 4 September 2005	Ferens Art Gallery, Hull
10 September – 16 October	Worcester City Art Gallery
22 October – 4 December	Plymouth City Museum and Art Gallery
10 December 2005 – 29 January 2006	Aberystwyth Arts Centre
4 February – 26 March	Tullie House Museum and Art Gallery, Carlisle

Exhibition organised by Jacky Klein, assisted by Clare Hennessy

Book designed by Peter Campbell
Art Publisher: Caroline Wetherilt
Publishing Co-ordinator: James Dalrymple
Sales Manager: Deborah Power
Printed in The Netherlands by Lecturis

Front cover: Lucien Métivet, *Au salon du cycle (At the cycling salon)* from *Le Rire*, 8 December 1894 (detail)
Back cover: Quentin Blake, original drawing for *Un Bateau dans le Ciel* (*A Sailing Boat in the Sky*), 2000 (Rue du Monde, Voisons-Le-Bretonneux) (detail)

Published by Hayward Gallery Publishing, London SE1 8XX, UK, www.hayward.org.uk
© Hayward Gallery 2005
Texts © the authors 2005
Artworks © the artists / estates of the artists (unless stated otherwise)

ISBN 1 85332 248 2

Hayward Gallery Publishing titles are distributed outside North and South America by Cornerhouse Publications, 70 Oxford Street, Manchester M1 5NH
(tel. +44 (0)161 200 1503; fax. +44 (0)161 200 1504;
email: publications@cornerhouse.org; www.cornerhouse.org/publications).

Contents

Preface

Quentin Blake is Britain's most popular and prolific children's book illustrator. During a career of 50 years, he has illustrated more than 300 books (including some for adults), and he can now be considered something of a national institution. His quick line and anarchic humour are instantly recognisable, and his vivacity as a draughtsman is matched by a tireless commitment to teaching and propagating the joys of drawing. For 20 years he taught illustration at the Royal College of Art (he was head of the Illustration Department from 1978 to 1986), and in 1999 he was appointed the first ever Children's Laureate, a post designed to raise the profile of children's literature. He is also a founding Patron of the Campaign for Drawing.

In All Directions follows on from the success of several exhibitions curated by Quentin Blake in recent years, including *Tell Me a Picture* at the National Gallery in 2001, the 2002–03 British Council touring exhibition *Magic Pencil*, and *A Baker's Dozen*, organised by Bury St Edmunds Art Gallery and then on tour in 2002–03. A survey of his own work was presented at Somerset House in London in 2004, and in Paris in 2005 he will select a temporary exhibition at the Petit Palais, *Les Demoiselles des Bords de Seine*, to coincide with the restoration and reopening of the museum.

In London, a Quentin Blake Gallery of Illustration is in development, where exhibitions – of which this is a forerunner – will promote and explore the art of illustration. That art, as Quentin observes, is distinguished from 'fine art' in ways that are sometimes uncomfortable; the distinction is arguably academic, the term 'illustration' often being used to connote a genre that is inherently minor, contingent and commercially motivated. However, we are reminded by this exhibition that many of the greatest artists of the past have turned their hand to illustration and the printed media. And the skill and imagination of many illustrators surpasses that of their peers in the 'fine arts'. In his essay, Quentin notes certain defining characteristics of illustration: an intimacy of scale – usually that of the printed page and related to the gesture of the hand – and often a narrative sequence or connection to a text and to purposes of reproduction. But it is the 'visual appetite', the desire to observe and record the world, and to imagine possible variations of it, that is celebrated in this exhibition.

Our thanks go firstly to Quentin: not only has he made the selection and written the catalogue, but he is also a significant lender to the exhibition in his own right. His generosity, modesty and contagious enthusiasm have made the organisation of the exhibition a real pleasure. Ghislaine Kenyon, currently Head of Learning at Somerset House, worked with him on the National Gallery exhibition; she initiated the conver-

sation that led to this exhibition. Suzanne Bosman assisted Quentin in the early stages of research for the exhibition, and Claudia Zeff's efforts as project director of the future Gallery of Illustration helped to inform the project at its start. Nikki Mansergh, Colleen Collier and Liz Whittingham in Quentin's office have provided invaluable assistance throughout.

We are most grateful to the museums, libraries and private collectors who have lent works to the exhibition: the Asia and Prints and Drawings Departments of the British Museum, the Imperial War Museum, the London Library, the National Art Library and the Victoria and Albert Museum, The Edward Gorey Charitable Trust and Richard Nathanson Fine Art, London. We also thank all those artists who have generously lent works from their collections and whose visions of travel – literal, metaphorical, satirical and magical – have given the show so much of its richness: Stephen Biesty, Harry Brockway, John Burningham, Christopher Corr, Dan Fern, Michael Foreman, David Gentleman, Su Huntley and Donna Muir, and Daniel Maja.

We extend our appreciation to colleagues in the host galleries, who have responded so positively to the exhibition: Christine Brady at the Ferens Art Gallery, Hull, Angela Bishop at Worcester City Art Gallery, Joanne Hall at Plymouth City Museum and Art Gallery, Eve Ropek at Aberystwyth Arts Centre and Fiona Venables at Tullie House Museum and Art Gallery, Carlisle.

Thanks are due to colleagues at the Hayward Gallery: Helen Luckett who wrote the technical glossary and produced the family activity guide and the film and reading area for the exhibition; Helen Faulkner and Matt Dixon for their work on the exhibition graphics; Mark King, Stephen Cook, Nicola Goudge, Jeremy Clapham, Andrew Craig and Geock Brown for the framing and packing of the show; Alison Maun and Imogen Winter who have co-ordinated the transport, insurance and tour; Dave Palmer, transport foreman; Caroline Wetherilt, Art Publisher, and James Dalrymple, Publishing Co-ordinator, for their work on the catalogue; Mike Fear for producing new photography; and Peter Campbell who has designed the book with enthusiasm and skill. Finally, thanks go to Jacky Klein who has worked closely with Quentin Blake on the organisation of the exhibition, assisted by Clare Hennessy, and helped in the early stages by Isabel Finch. Their dedication, care and concern for every detail have ensured the quality of both this book and the exhibition it accompanies.

Roger Malbert
Senior Curator, National Touring Exhibitions, Hayward Gallery

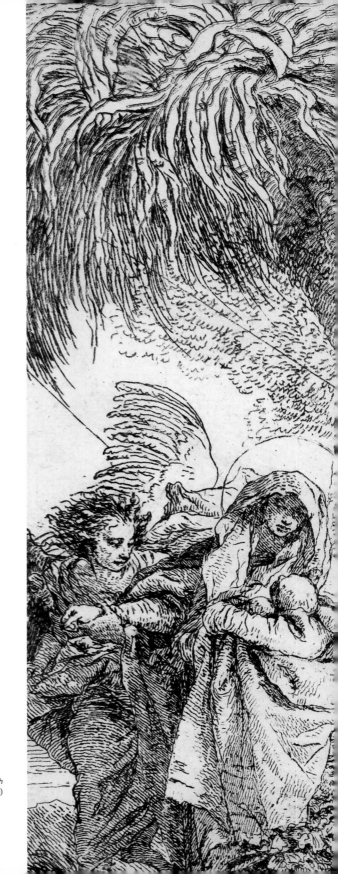

Giandomenico Tiepolo, *The Virgin and Child with an angel, Joseph with the donkey.* From the series *The Flight into Egypt*, 1753. Etching (detail)

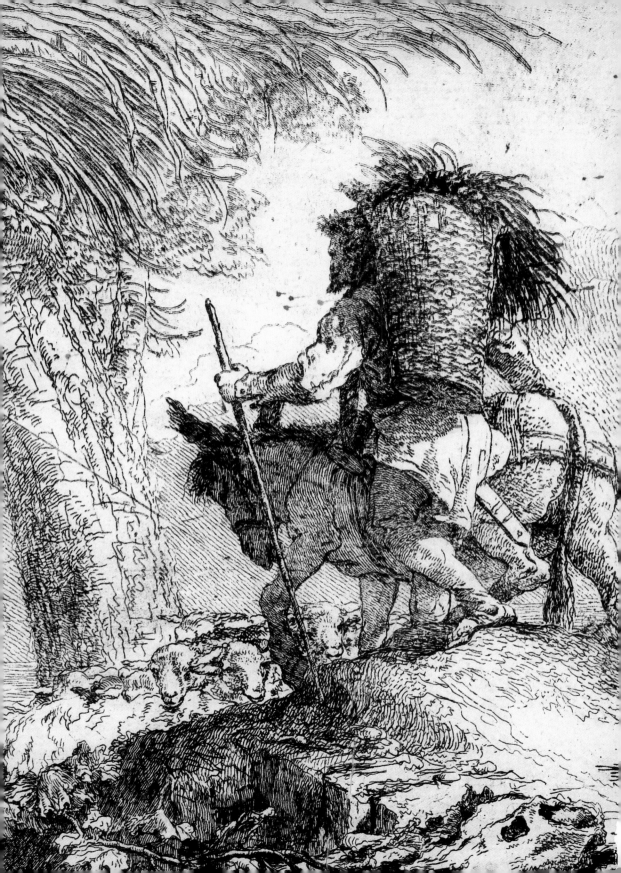

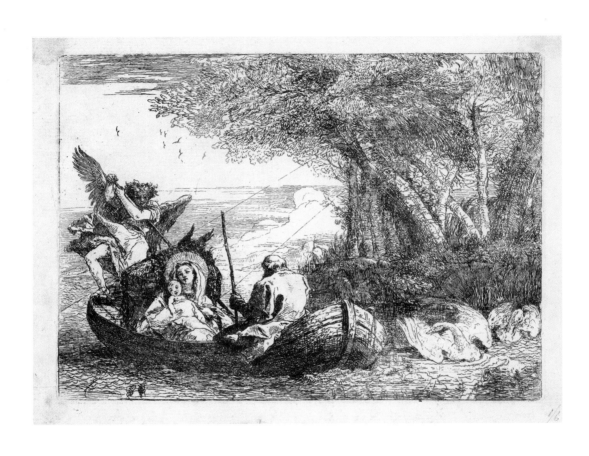

Giandomenico Tiepolo, *The Holy Family being rowed by an angel in a boat.* From the series *The Flight into Egypt*, 1753. Etching

In All Directions Quentin Blake

S O WHERE are we off to? If I don't find it easy to give a simple account of the route of this excursion it is partly because it was conceived with a double purpose. The first is to look at the way travel – or rather, the range of ways we get from one place to another – has been shown in illustration. Included in that, inevitably, there will be the artist's reactions, and sometimes the reactions of fortunate or unfortunate travellers. The pictures here show an assortment of images from over the past 300 years; but of course it is only a tiny selection – and a completely personal one – from centuries of mechanical development and social change.

The second purpose is to take the opportunity to display the possible diversities of illustration. The history of that activity is in many ways related to technical developments, and one way of telling that story would be in terms of the development of printing techniques. Though the history of transport is similarly linked to technical discovery, the two developments are unfortunately not geared to each other in simple chronological sequence. So, for better or worse, this sequence of depictions has to embrace the haphazard: the images are arranged by appearance and association.

Perhaps it makes sense to begin with the most primitive form of transport we have here. The donkey comes with its reputation of being slow, wayward, obstinate and uncomfortable. In Giandomenico Tiepolo's 1753 account of the Flight into Egypt we encounter third-class transport with a more than first-class passenger. Giandomenico, as the son and assistant of the great eighteenth-century Venetian painter Gianbattista Tiepolo, was able to share in that master's thrilling enthusiasm, compositional poise and *élan*, and his draughtsmanly insouciance, so it is not surprising that much of the charm of these engravings comes from the way that the mother and child and the hirsute ordinary donkey are graced on every side by the leaning attentions of angels, their wings reaching out as feathery diagonals to the foliate richness of surrounding trees. A breeze flows through these pictures, and there is space and distance in them too, and a simplification and ordering of the elements that compose them and that make it easy to believe that they were works that Goya looked at with interest.

These prints are able to show us one way in which the road of depiction broadened into the possibility of the multiplied image, one that was available for a whole new class of owners. Later, in the mid-nineteenth century, Victor Hugo gave his own broad-brush version of this change in the transformation from the great corporate energies of the medieval cathedrals to the multifarious artworks made possible by the development of printing. In that context it may be interesting to think of the young

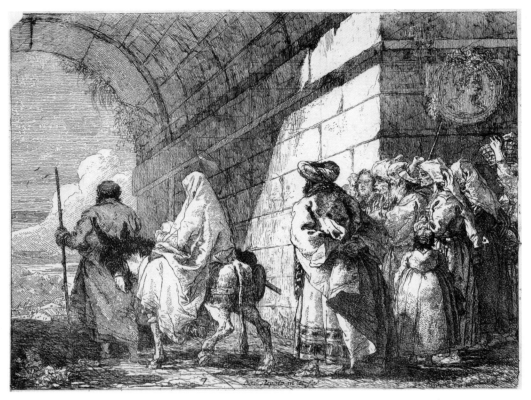

Giandomenico Tiepolo, *Joseph leading the Virgin and Child through an archway.* From the series *The Flight into Egypt*, 1753. Etching

Giandomenico assisting his father in the decoration of the Residenz of Carl Philipp von Greiffenklau in Würzburg in Germany and at the same time producing this series of images that take us, in their distinctive way, into the history of sequential illustration; a path that leads, if you are inclined to follow it, as far as the strip cartoon and the graphic novel.

TIEPOLO's engravings were etchings – a method where acid eats into the lines drawn on a coated metal plate by the etcher's needle, and which records not varying pressures but, with great sensitivity, the slightest movement of the artist's hand. To that hand at that moment the viewer is very close indeed. Etching as a technique for the multiplication of images was still flourishing later in the eighteenth century, and was present to help acknowledge the arrival of that new-fangled object

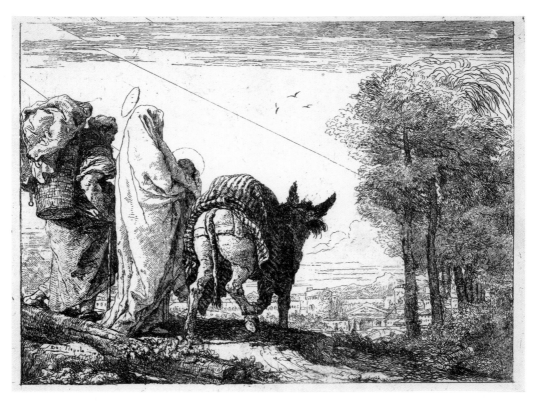

Giandomenico Tiepolo, *The Holy Family walking beside the donkey.* From the series *The Flight into Egypt*, 1753. Etching

that later turned out to be the bicycle. In the hands of the Cruikshank family, their collaborators and competitors, etching was put to very different purposes from those of the Venetian Tiepolo. The aim was now comic, satirical; these prints were a commentary on the times, offered in print-sellers' windows, to be purchased and displayed at home or kept in portfolios as a source of pre-television home entertainment. Individually tinted, they could never be thought of as representations of paintings that existed elsewhere; they come with their own graphic style. The nervous etched line describes unequivocally the caricature profile, the exaggerated gesture of hysteria or collapse, the bows and swags of the grotesque vagaries of fashion. It was also perfect for those long, wobbly speech balloons filled with spidery writing which provide the commentary on these scenes and, more often than not, are illegible in any but the best modern reproductions.

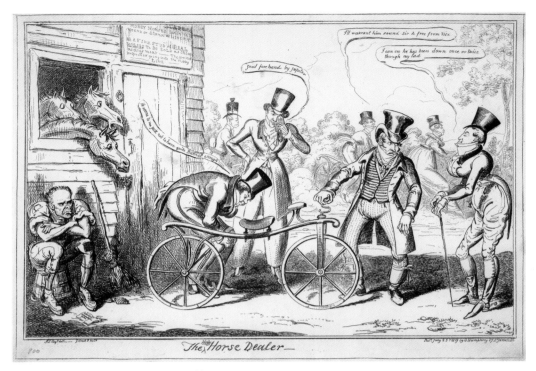

George Cruikshank, *The Hobby Horse Dealer*, 1819. Etching

It was, in fact, as a freakish aberration that these satirical artists mostly saw these first prototypes of the bicycle – and as a useful device for showing their victims in even more ludicrous postures. It was perhaps with something of a second thought that George Cruikshank was for a moment able to take the bicycle seriously enough to see it becoming the horse's replacement. As we know, the story did not altogether work out like that – but in Cruikshank's *The Hobby Horse Dealer* of 1819 we see the fanciers of horseflesh transferring their sage assessments to the machine.

As George Cruikshank grew up and established his independence from his father, he moved into a less satirical humour based primarily on observation. Nobody had a more intimate sense of London life in the first half of the nineteenth century than he had, a better knowledge of the backstreets and front parlours, the small rituals and happenings of daily life. Who was better equipped to match the genius of the young Charles Dickens as Cruikshank in his illustrations of *Oliver Twist* or *Sketches by Boz*? The etched lines act out gestures of sometimes almost manic intensity, or gather together to evoke the darkness of alleys, the subtle light of urban dawn and dusk.

As the end of the century approached the bicycle found itself securely

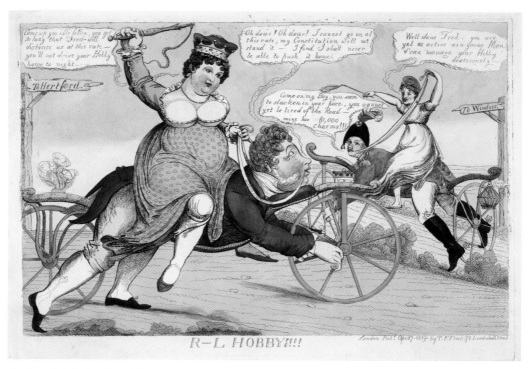

after **George Cruikshank**, *R–L Hobby's!!!*, 1819. Hand-coloured etching

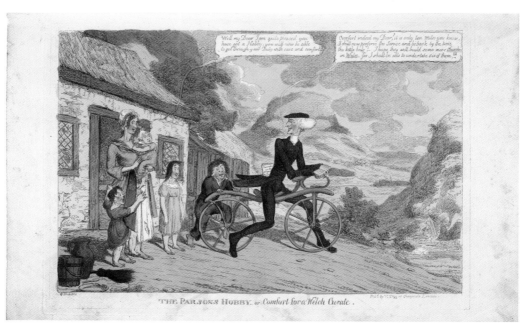

Charles Williams, *The Parson's Hobby – or – Comfort for a Welch Curate*, 1819. Hand-coloured etching

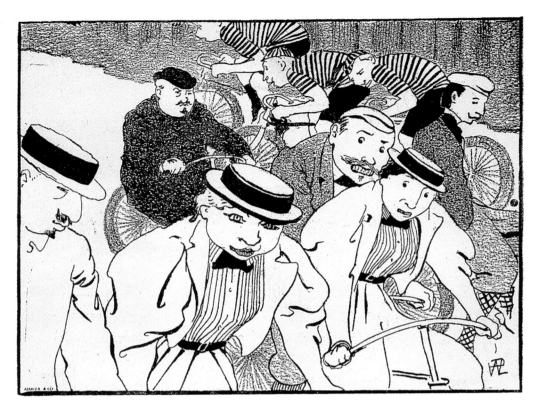

Hermann-Paul (René Georges Hermann-Paul), *Biches au Bois (Frightened Animals)*. From *Le Rire*, 8 December 1894. Lithograph

domesticated: and it was perhaps in France that cycling was most fully taken into the culture and consciousness, both for racing and for the more relaxed *promenade au vélo* or bicycle ride. Both are present in a drawing by Hermann-Paul in *Le Rire*, probably the best-known of many similar humorous magazines to be found in turn-of-the-century Paris. It is from *Le Rire* that our other reflections of the world of the bicycle have been taken. The contrast between these French magazines and *Punch* on the British side of the channel is marked. *Punch* stayed with the black-and-white of wood engraving until the advent of the photographic line-block. *Le Rire* and its fellows embraced the idea of colour, which appeared on the cover and generally several other pages. Here the tradition was that of the lithograph – so that two or three colours would overprint ingeniously to produce yet more.

Another of our artists of the bicycle is Lucien Métivet. He is little known now, but the painter Walter Sickert, who had an eye for the illustrators of the popular press, was happy to observe: 'I buy every paper in which there is a chance of a drawing by Métivet, for their beauty as drawings and their wit' (*Morning Post*, 6 June 1922).

N° 5. — 8 Décembre 1894. 15 centimes.

Le Rire

JOURNAL HUMORISTIQUE PARAISSANT LE SAMEDI

Un an : Paris, 8 fr.
Départements, 9 fr. Étranger, 12 fr.
Six mois : France, 5 fr. Étranger, 6.50

M. Félix JUVEN, Directeur. — Partie artistique : M. Arsène ALEXANDRE
La reproduction des dessins du RIRE est absolument interdite aux publications, françaises ou étrangères, sans autorisation

122, rue Réaumur, 122
PARIS
Vente et Abonnement
9, rue Saint-Joseph, 9

LE « RIRE » AU SALON DU CYCLE
Dessin de L. MÉTIVET.

— Depuis que le cyclisme est entré dans les mœurs, le monde marche maintenant comme sur des roulettes.

Lucien Métivet, *Au salon du cycle (At the cycling salon).* From *Le Rire*, 8 December 1894. Lithograph
Since cycling became a feature of life, the world now runs as if on wheels.

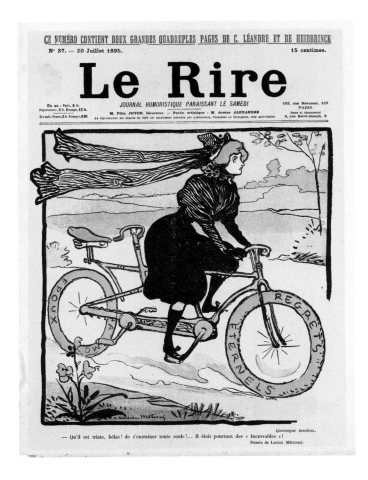

CE NUMÉRO CONTIENT DEUX GRANDES QUADRUPLES PAGES DE C. LÉANDRE ET DE HEIDBRINCK

Nº 37. — 20 Juillet 1895. 15 centimes.

Le Rire

JOURNAL HUMORISTIQUE PARAISSANT LE SAMEDI

Un an : Paris, 8 fr. 122, rue Réaumur, 122
Départements, 9 fr. Étranger, 12 fr. PARIS

Six mois : France, 5 fr. Étranger, 6.50 M. Félix JUVEN, Directeur. — Partie artistique : M. Arsène ALEXANDRE Vente et Abonnement
 La reproduction des dessins de RIRE est absolument interdite aux publications, françaises ou étrangères, sans autorisation 9, rue Saint-Joseph, 9

Quousque tandem.

— Qu'il est triste, hélas! de s'entraîner toute seule!... Il était pourtant des « Incrovables »!
Dessin de Lucien Métivet.

Lucien Métivet, *'Qu'il est triste, hélas! de s'entraîner toute seule!...'*
From *Le Rire*, 20 July 1895. Lithograph

Alas, how sad it is! To travel all alone!...
He was after all supposed to be one of the 'unburstables'!

(top right) **Honoré Daumier**
'Allons donc... que diable cocher, votre coucou n'avance pas!...'
From the series *Les Chemins de Fer (The Railways)*,
published in *Le Charivari*, 9 June 1843
Lithograph

-To hell with it, coachman, you are getting nowhere!...
-We have time!... we have time... I'm not taking you to the moon... if you want to get there, you should take the train!... I am just going as far as Bougival... and as the old German saying goes: *'qui va piano va sainemento'* (he who goes slowly goes safely)

(bottom right) **Honoré Daumier**
*Une diligence prise d'assaut
(A coach taken by storm)*
From the series *Les Chemins de Fer (The Railways)*,
published in *Le Charivari*, 28 July 1843
Lithograph

Hell! What could I have been thinking of getting involved in this carry-on with a wife and two kids!... Ah! The days of the Fountains of Versailles, the only truly happy fathers are those without children!...

Part of the interest of Métivet, I believe, is that he was one of a new generation of artists whose style was developed by, and formed for, the prospect of publication. Many drawings before this time might have been put to various uses; Métivet solely had print in view. The wheels on his mourning tandem are the wreathes from a typical French funeral: they are a visual pun, and the drawing has a clarity that makes this point, giving a signal rather than a notation of perceived reality.

THE ADVENT of the railway train established a new level of possibility in the romance of travel, though it was unsurprisingly greeted by satire and incredulity. In the main it was the discomfort rather than the danger that offered subject-matter to Honoré Daumier. We see more of the passengers than we do of the trains: what he wanted to draw was people, and the play of reaction in their gestures and physiognomy.

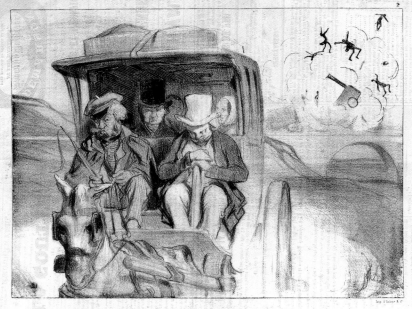

— Allons donc... que diable cocher, votre coucou n'avance pas!.....
— Nous avons le temps!... nous avons le temps!... je ne vous conduis pas à la lune... si vous vouliez arriver là fallait prendre le chemin de fer...moi je ne vais que jusqu'à Bougival...et comme dit le proverbe allemand...qui va piano va sainement!..

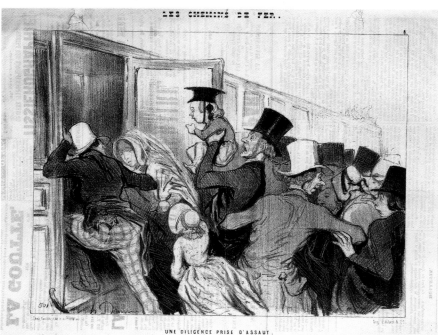

501

UNE DILIGENCE PRISE D'ASSAUT.

Sacristi! quelle idée ai-je eue de venir me fourrer dans cette bagarre avec une femme et deux moutards! ah! les jours des grandes eaux de Versailles, les seuls pères de famille véritablement heureux sont ceux qui n'ont pas d'enfans!

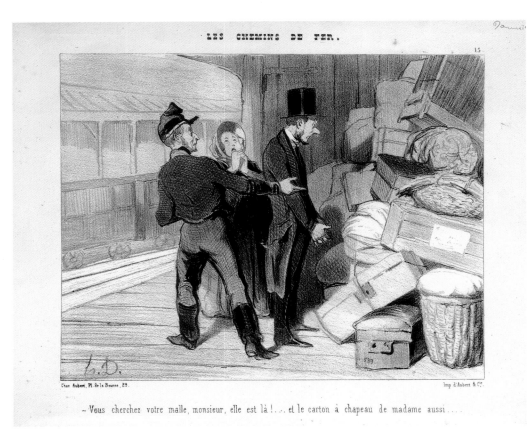

Honoré Daumier
'*Vous cherchez votre malle, monsieur, elle est là!...*', from the series *Les Chemins de Fer (The Railways)*,
published in *Le Charivari*, 19 December 1843. Lithograph

You're looking for your trunk, Sir, there it is!... and Madam's hat box too...

Daumier himself was the beneficiary of the discovery and commercialisation of lithography. His pictures, appearing regularly and frequently in the weekly Parisian papers, were drawn directly onto the stone, so that every page torn from the mid-nineteenth-century paper *Le Charivari* is in fact an original. The richness of the litho crayon, the blackness of the litho ink, seem to make an ideal medium for Daumier's depiction of the everyday life in the theatres, courts, streets and bedrooms of contemporary Paris. The celebrated observation of Charles Baudelaire that Daumier had '*du Michelange sous la peau*' (some Michelangelo under the skin) once again invokes Victor Hugo's contrast between the Church and the individual – this time between the thronged fresco and the 4,000 lithographs of this urban *comédie humaine*.

Honoré Daumier
Le danger de s'assoupir en voyage (*The danger of dozing off during travel*)
From the series *Les Chemins de Fer (The Railways)*, published in *Le Charivari*, 28 October 1843
Lithograph

-Wake up Sir, and get out of the coach!...
-Where are we, conductor?...
-But in Rouen, by God!
-In Rouen, but I only wanted to go as far as Poissy, where I have been invited for dinner tonight at 5 o'clock!...
-Don't worry, there is a way we can fix that... take the next train back and you will arrive there tomorrow morning just in time for lunch... it's almost the same thing...

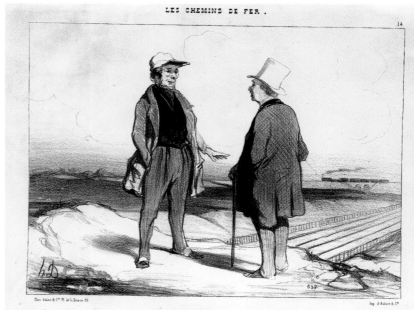

LES CHEMINS DE FER.

LE DANGER DE S'ASSOUPIR EN VOYAGE.

– Reveillez-vous donc, monsieur, et descendez de voiture !... – Où sommes-nous, conducteur ? – Mais à Rouen parbleu !– A Rouen, et moi qui ne voulais aller que jusqu'à Poissy où je suis invité à dîner aujourd'hui à cinq heures précises ! – Eh ben! il y a manière d'arranger ça ... en prenant le premier convoi vous y arriverez demain matin de bonne heure ... pour déjeuner c'est à peu près la même chose ...

Honoré Daumier
'Comment il va y avoir des chemins de fer atmosphériques!...'
From the series *Les Chemins de Fer (The Railways)*, published in *Le Charivari*, 17 December 1843
Lithograph

-What do you mean, there are soon going to be air trains!...
-But of course, Sir... you see, it will then be very easy to establish a connection between Dover and Calais... but of course, the project is still up in the air!...

LES CHEMINS DE FER .

– Comment il va y avoir des chemins de fer **atmosphériques** !....
– Oui monsieur ... vous comprenez dès lors qu'il sera très facile d'en établir un de Douvres à Calais il est vrai que c'est encore un projet en l'air !...

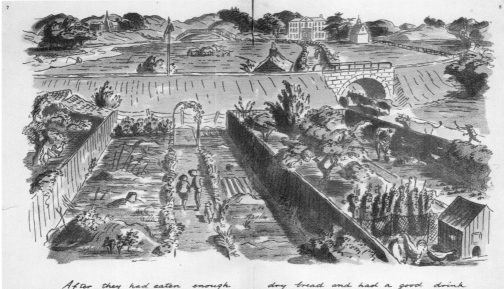

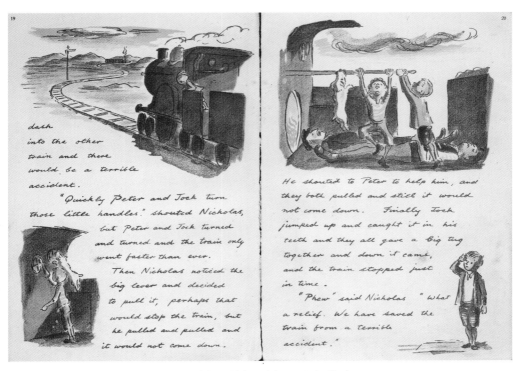

(above and right) **Edward Ardizzone**, Double page spreads from *Nicholas and the Fast-Moving Diesel*, 1948
(Eyre and Spottiswoode, London). Lithographs

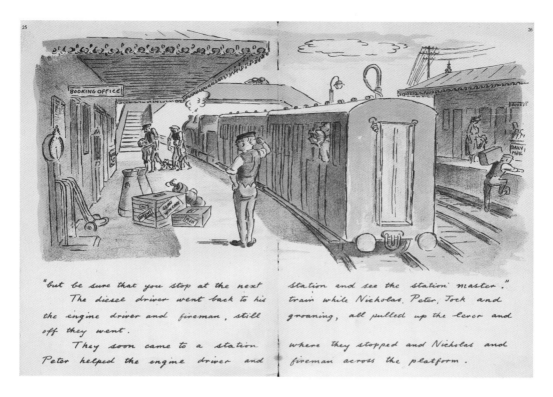

"but be sure that you stop at the next station and see the station master."
 The diesel driver went back to his train while Nicholas, Peter, Jock and
the engine driver and fireman, still groaning, all pulled up the lever and
off they went.
 They soon came to a station where they stopped and Nicholas and
Peter helped the engine driver and fireman across the platform.

As Daumier's railway observations are lithographic originals, so are the pages from Edward Ardizzone's *Nicholas and the Fast-Moving Diesel*, first published in 1948. Lithography was a method that was unusual for a children's book, and a later reappearance of the title was actually re-drawn by the artist using a different technique: the first edition, however, consisted of genuine lithographs, with four separate colour printings. Even the text was hand-written and one has the sense that it was all created specifically for Ardizzone's son Nicholas, who is also the hero of the tale. It's an adventure not so very different from those experienced by Little Tim in the sequence of books that bear *his* name, though here we are not at sea but on a railway line where a traditional puffing steam train nearly gets crashed into by the fast-moving diesel. In contrast to the diesel's streamline form is the homely familiarity of the steam engine with its two sympathetic character-actor train drivers seated as though around their own fireside for a cup of tea. Although his book is in colour, Ardizzone, like Daumier, creates a sense of three-dimensional reality by tone, by the fall of light crosswise on the forms and figures. He doesn't, however, have Daumier's need to explore the distortions of individual faces, or the idiosyncrasies of gestures. Ardizzone's instinct is to generalise forms while at the same time making them substantial: the individuality of Nicholas is not so insistent that the reader finds it hard to see himself in the story.

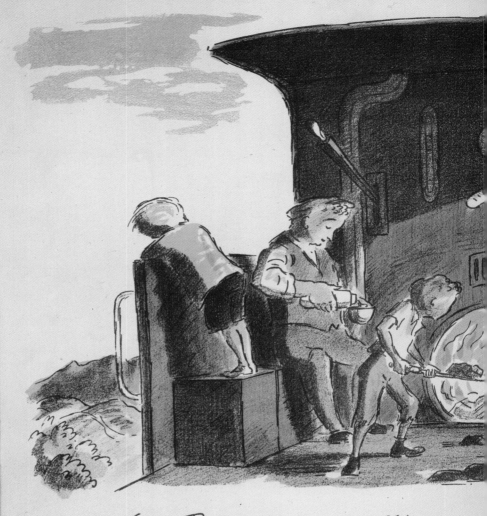

Soon Peter was shovelling coa[l]
by pushing lumps of coal along the
busy leaning with his head out of
carefully to see if the signals were up
Two cups of tea, one for the driver an[d]

Edward Ardizzone, Double page spread from *Nicholas and the Fast-Moving Diesel*, 1948 (Eyre and Spottiswoode, London). Lithograph

A nice cup of
tea Mate

...nto the fire while Jock helped him
...floor with his nose and Nicholas was
...he cab watching the railway line very
... down. The fireman poured out
...me for himself. BUT ———

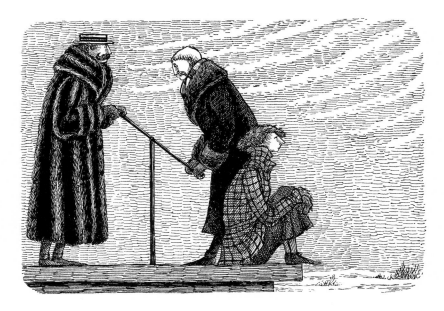

Some months went by, and still they had not returned to Willowdale.

(above and right) **Edward Gorey**, Illustrations from *The Willowdale Handcar or The Return of the Black Doll*, 1962
(The Bobbs-Merrill Company Inc., Indianapolis/New York). Pen and ink. Reproductions from Bloomsbury Publishing Plc, London 2004

Edward Gorey's *The Willowdale Handcar* (1962) presents us with a very different railway experience. It is possible to understand the enthusiasm that this American artist expressed for the work of Ardizzone, though in Gorey's work the accumulated shading and the evocative evening light are used to very different effect. Gorey seems to have discovered his preferred way of working very early on, and his incomparable legacy is a series of illustrated books, produced over 40 years, perfect in their atmosphere of sinister quaintness. That they are also both funny and beautiful owes a great deal not only to Gorey's imagination but also to his choice of moment, his discretion

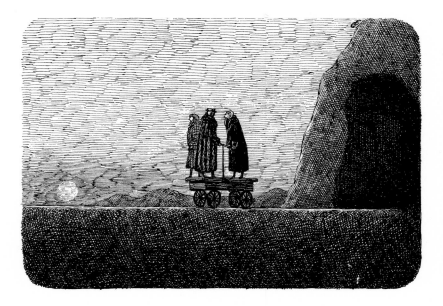

At sunset they entered a tunnel in the Iron Hills and did not come out the other end.

in the presentation of catastrophe, and his unerring sense of black-and-white on the page. *The Willowdale Handcar,* with its inexplicable incidents and satisfying characteristic conclusion, is a fine example.

If the train as an object speaks to the imagination, it speaks most eloquently, I suppose, in the form of those cowcatchered giants created to deal with the enormous spaces of North America and Siberia. It is one of these that John Burningham shows us in his children's book *Oi! Get Off Our Train* (1989). Burningham is one of those artists who made a significant contribution to the fresh flowering of the children's

John Burningham, Original drawing for *Oi! Get Off Our Train*, 1989 (Jonathan Cape, London). Pencil, ink, pastel and gouache on paper mounted on board

picture book in Britain in the 1960s. This new enthusiasm was no doubt partly due to our at last getting our heads up and looking round after the Second World War, but also due to the more ready availability of four-colour halftone printing, so that the picture book you were holding in your hands was in fact a series of reproductions of paintings. The message of *Oi! Get Off Our Train* is about endangered species. Much of the humour comes from the young hero and his dog (who, in the boy's dream, both

John Burningham, Original drawing for *Oi! Get Off Our Train*, 1989 (Jonathan Cape, London). Pencil, ink, pastel and gouache

drive the train) as well as the engagingly gauche band of creatures who climb on board, but the poetry of the book lives in the scenes of the train on its journey through land-scapes of changing mood and atmosphere. The four-colour reproductions allow us to savour a wonderful air of improvisation – we can almost sense Burningham bring-ing together the various textures, the veils and scrapings of colour, as he creates the weather before us.

(above and bottom right) **John Burningham**, Original drawings for *Oi! Get Off Our Train*, 1989 (Jonathan Cape, London).
Pencil, ink, pastel and gouache on paper mounted on board

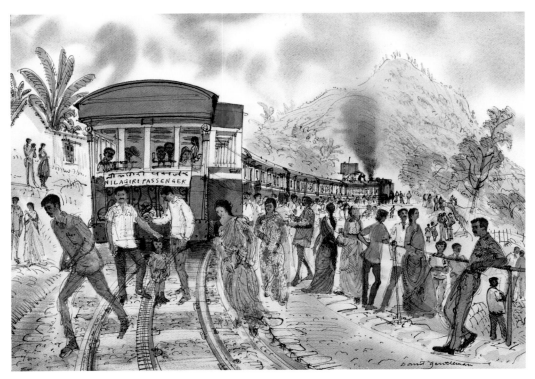

David Gentleman, *Hillgrove station on the Mettupalayam-Udagamandalam (Ooty) line*, 1993. Pen and wash

By contrast, an artist who is inspired by what he sees in front of him is David Gentleman. He has illustrated (as well as written) books about the coastline of Britain, about London and Paris, Italy and India. The drawings here, done in an Indian train station, in the carriages and, by his special request, on the footplate of a steam train struggling uphill in the mountains, combine authenticity with the charm and immediacy of the moment – we sense that we are there with him, where the ceiling fans are really needed.

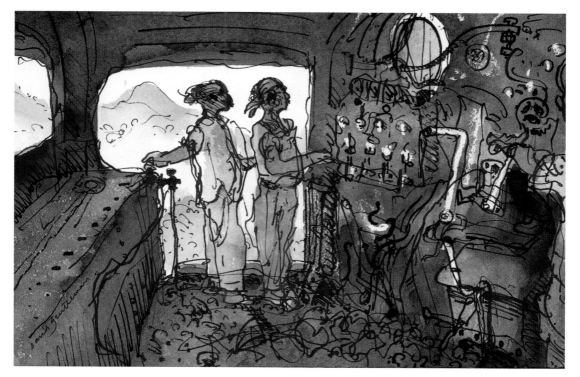

David Gentleman, *In the engine during the climb up Ooty: Taking a break,* 1993. Pen and wash

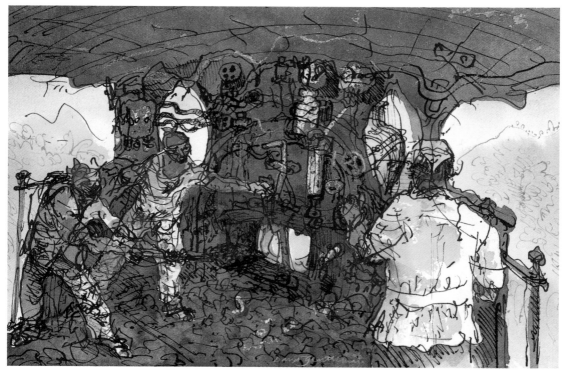

David Gentleman, *In the engine during the climb up Ooty: Stoking the fire,* 1993. Pen and wash

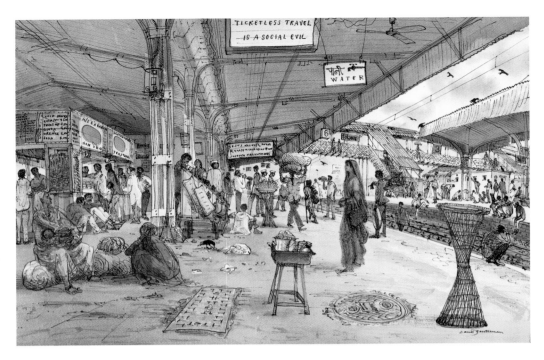

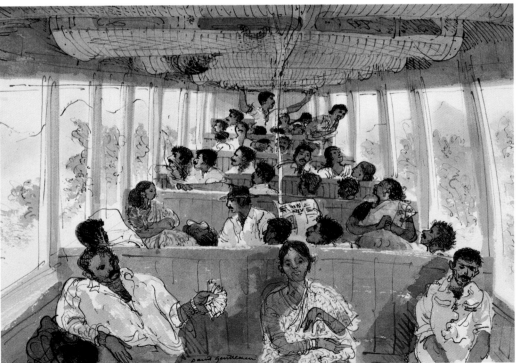

(top) **David Gentleman**, *Manmad Junction station: Waiting for the Goa-Delhi train*, 1993. Pen and wash
(bottom) **David Gentleman**, *Second class carriage interior on the train to Udagamandalam (Ooty)*, 1993. Pen and wash
(right) **David Gentleman**, *Milly, Tabby and Tom on the Jaipur-Agra express*, 1993. Pen and wash (detail)

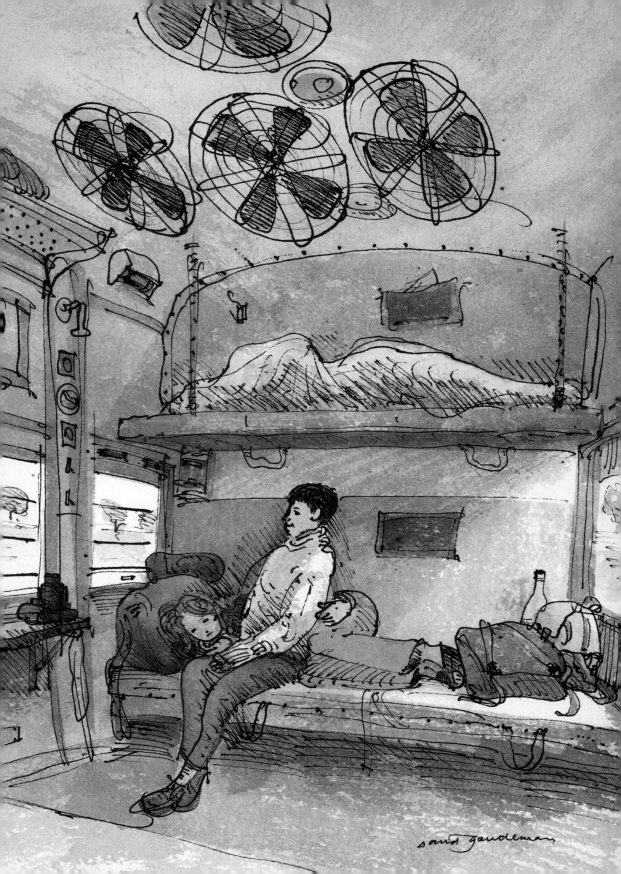

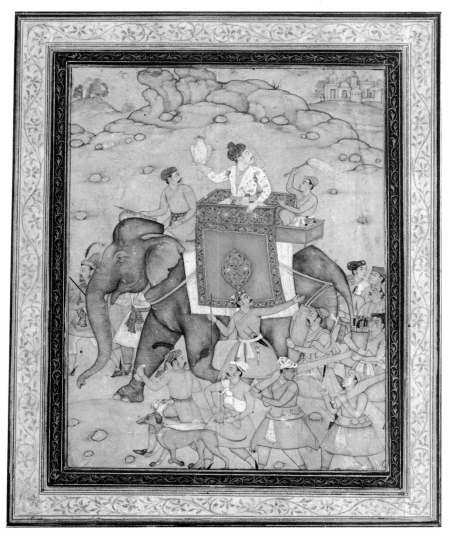

Anon, *Akbar hawking on an elephant*, c.1600–05. Opaque watercolour and gold

THE MUGHAL miniatures that show elephants – the quintessential Indian mode of transport – being used to help make love and war are a striking contrast to David Gentleman's lyrical reportage – though they too succeed triumphantly in being decorative and informative in detail, as well as calmly dramatic. They are amongst the few images, incidentally, in this selection that are unique; they were created for private contemplation, but their intimacy of scale and narrative strength make them works that an illustrator must regard with special respect.

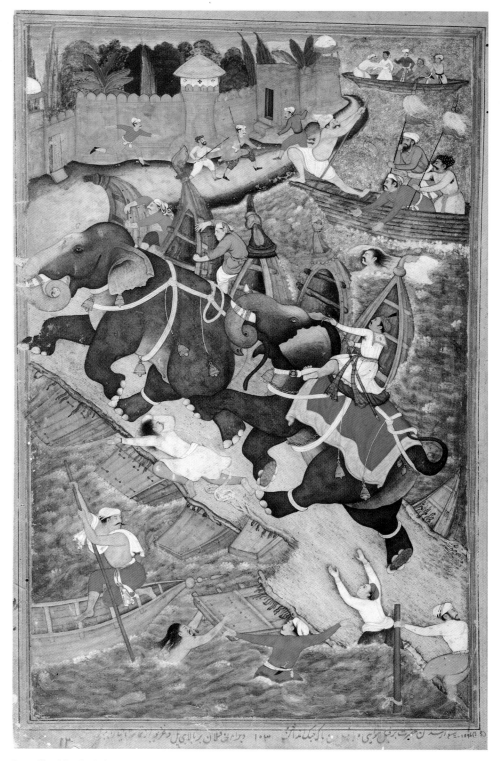

منسوب به لال ۱۰۳ دو جانب سلطان بر بلائی ... ریخت ۱۳۰۱(۱)

Anon, *Akbar riding the elephant Hawa'i pursuing another elephant across a collapsing bridge* (left panel), *c*.1590–95. Opaque watercolour and gold

I N THE GROWING surge of international tourism in the second half of the twentieth century it is not hard to identify a group of travellers who had no choice over their destination: servicemen and women in their overseas postings. For many this would be their first encounter with a country other than their own, and not all had the good fortune to bring their new experiences home with them.

If amongst these depictions of travel in times of conflict I invite us to look first, unchronologically, at Linda Kitson's drawings from the South Atlantic it is because they represent the most direct response to this situation. On the basis of an exhibition of life and work in Fleet Street, Linda Kitson was approached in 1982 by Leonard Rosoman of the Imperial War Museum's Artistic Records Committee (himself a painter and illustrator, and war artist of distinction from the Second World War). The project in view was to accompany the Task Force on the QE2 to their base on the island of Ascension, and to draw the life there.

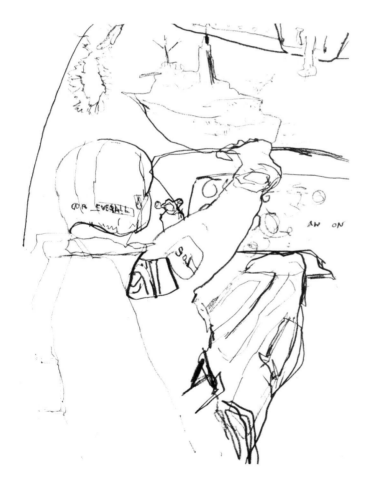

Linda Kitson
Looking Down on the QE2 from a Sea King Helicopter – 'My first flight with 825 Squadron', May 1982, 1982
Conté crayon

Linda Kitson
Flight Deck Crew and Sea King 97, 16 May 1982, 1982
Conté crayon

(pp.38–39)
Linda Kitson
Disembarking Troops to San Carlos Settlement, 2 June 1982, 1982
Conté crayon

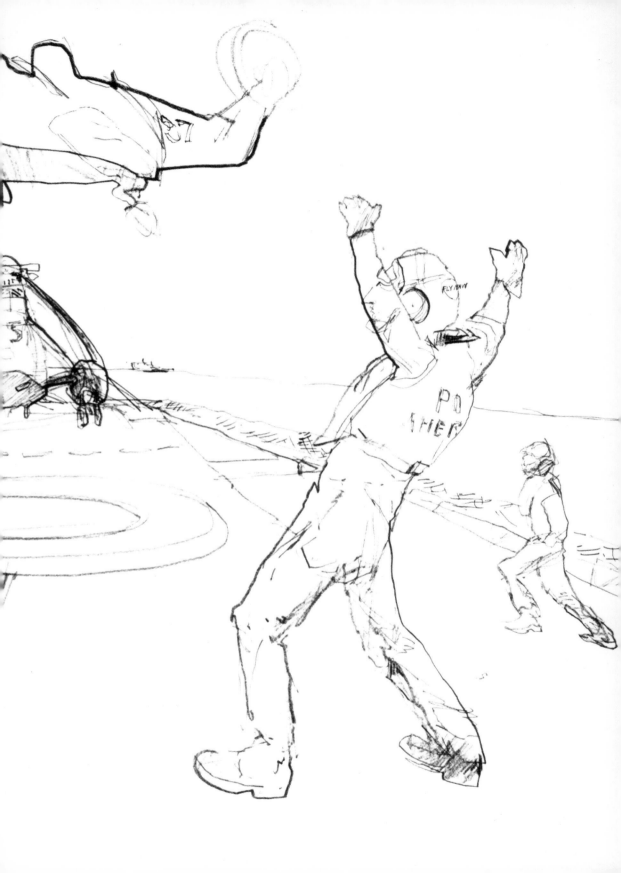

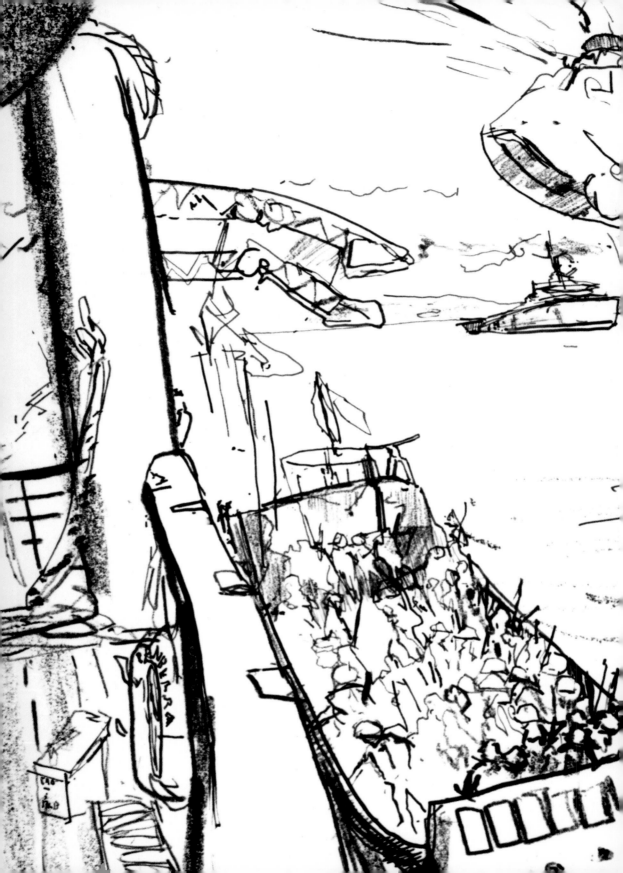

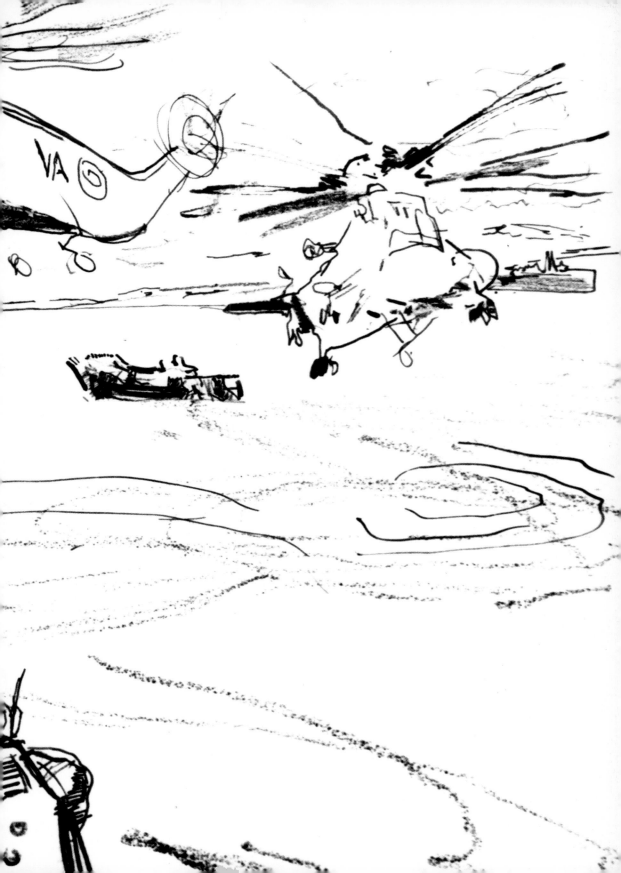

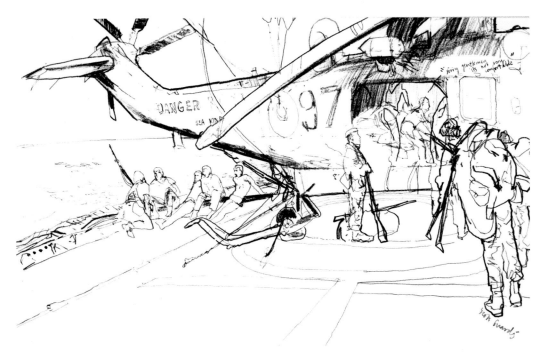

Linda Kitson, *Six hundred men a day go through 'Heli-training', 11 May 1982*, 1982 . Conté crayon

However, the QE2 passed Ascension in the night, and those who needed to stay there were helicoptered off the ship. As Kitson didn't find it necessary to insist on that detail of her assignment, she went on to the Falklands with the military and landed there. She spent the next two months or so with 5 Infantry Brigade and drew constantly, at a rate of between five and ten drawings a day, in dangerous circumstances and sometimes sub-zero temperatures to which only penguins are adapted.

The most striking form of transport of that conflict – as, it seems, of any modern conflict – was the helicopter: the noise of their engines was the constant background, Kitson remembers, to life in the Falklands. She travelled in helicopters (the chances of escaping from a helicopter crash are, apparently, extremely small) followed by her art materials and drawings in a tin trunk marked with instructions for it to be returned to the Imperial War Museum if it survived and she did not.

The War Artists scheme originated in the First World War, and those artists already adapted to the abstract formalisations of the avant-garde seemed specially prepared to depict the mechanisation of conflict and the consequent ruthless destruction: none more so than C.R.W. Nevinson. His lithographs of First World War biplanes, with their aerial points of view, match the flying machines with the ordered geometric divisions of the French landscape below.

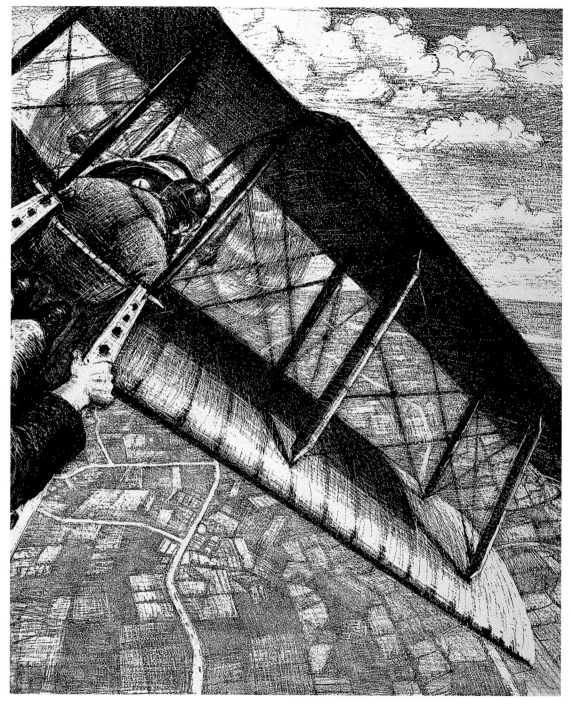

C.R.W. Nevinson, *Banking at 4,000 Feet.* From the series *'Britain's Efforts and Ideals': Making Aircraft,* 1917. Lithograph

Brian Robb's drawings, by contrast, were not commissioned as reportage, although they tell us a great deal about the circumstances of everyday life in the Western Desert of North Africa in the early 1940s during the Second World War. They were drawn in the spare moments of a soldier's life and published, for their entertainment value, in services magazines with names such as *Crusader* and *Parade*. At the outbreak of war Brian Robb was a painter and illustrator whose cartoons appeared both in *Punch* and *Night and Day*, that brilliant but short-lived English imitation of *The New Yorker*. These army drawings are imbued with the same quirks of his own hand and vision. After the war Robb found fresh scope for his idiosyncratic talents in the illustration of the more eccentric classics (*Tristram Shandy, The Golden Ass*) and, later, in children's books.

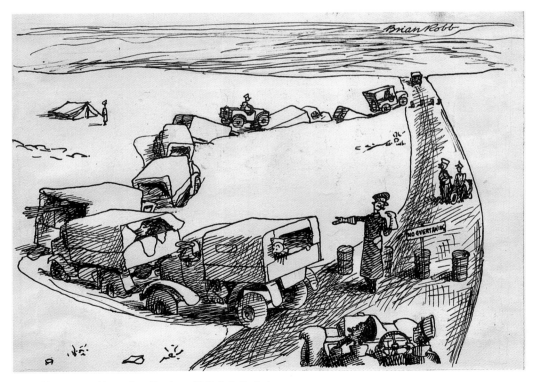

Brian Robb, *No. 10: 173rd Extraordinary Diversion and Traffic Reduction Post.*
From the series *My Middle East Campaigns: Little-known Units of the Western Desert*, 1944. Pen and ink

Brian Robb, *No. 22: No. 386 Road Obstruction Coy.*
From the series *My Middle East Campaigns: Little-known Units of the Western Desert*, 1944. Pen and ink

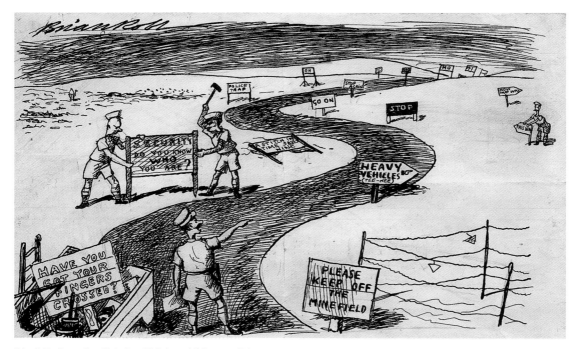

Brian Robb, *No. 21: No. 3 Notice Board Painting and Maintenance Unit.*
From the series *My Middle East Campaigns: Little-known Units of the Western Desert*, 1944. Pen and ink

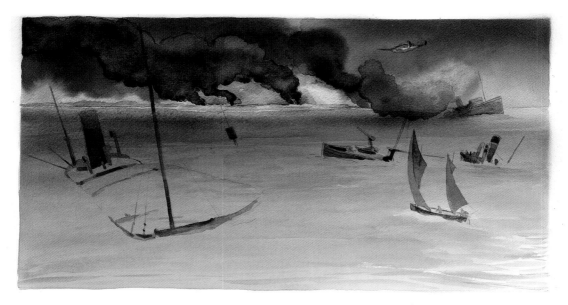

(above, and top and bottom right) **Michael Foreman**, Original drawings for *The Little Ships*, 1997 (Pavilion Books, London). Watercolour

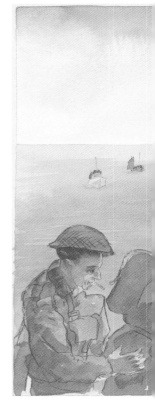

The works of Kitson, Nevinson and Robb are in their very different ways the reports of witnesses; Michael Foreman's pictures for *The Little Ships* (1997) represent by contrast a straightforward illustration commission. They were researched from available visual material but, though the artist would have been too young to be very aware of the circumstances of the retreat from Dunkirk, with the use of every available small boat to bring the troops off the French beaches, nevertheless these depictions are not in any sense cold or at arm's length. In *War Boy* (1989) Michael Foreman has written and illustrated a vivid reminiscence of a war-time boyhood in Lowestoft, with first-hand memories of soldiers and their equipment; and his sense of family roots and family loss inform *War Game* (1989), his account of incidents in the trenches in the First World War. Additionally, the artist brings to the task a hand and an eye enriched by long experience both of drawing from life in innumerable countries and of the skilled manipulation of watercolour, so that our sense of these pictures is that they are convincing without any self-conscious air of studied verisimilitude: they have their own quiet documentary authority.

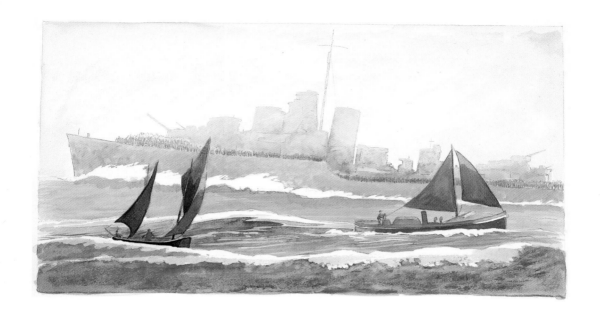

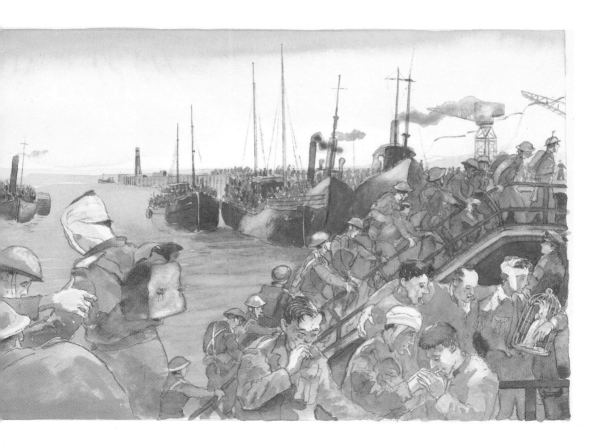

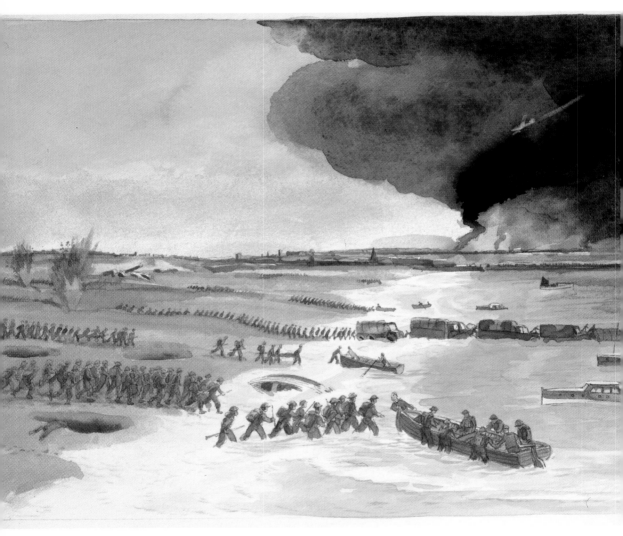

Michael Foreman, Original drawing for *The Little Ships*, 1997 (Pavilion Books, London). Watercolour

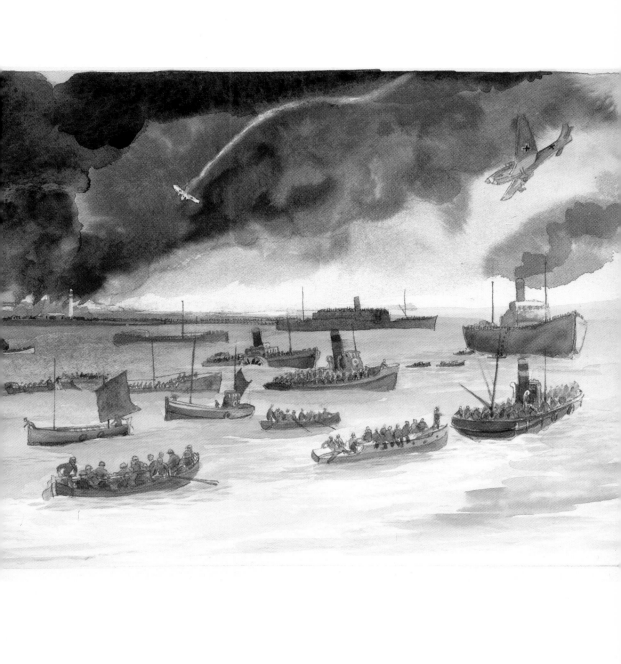

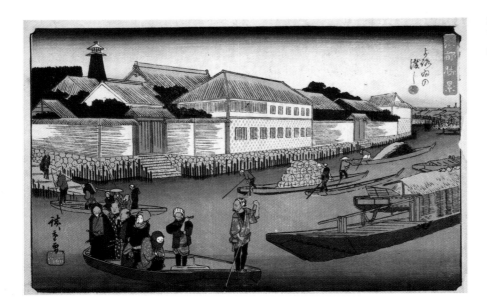

Utagawa Hiroshige
*Crossing the Yoroi
Waterway, c.1837*
Colour woodblock

I F WE RETURN to the nineteenth century of the print makers of Japan – of masters such as Hiroshige, Kuniyoshi and the great Hokusai – we find a different treatment of waterborne transport and its attendant emergencies. These complex images are able to be both decorative and specific with narrative information, the long curved keels and prows of the boats re-echoed in the rhythm of the waves. Curious to think that as the flattened perspective of these prints attracted and influenced Western painters later in the century, the same effects were disappearing under Western influence in the prints themselves. Curious too perhaps to reflect – especially for those who have sensed the sometimes uncomfortable distinction between illustration and fine art – that this division, nurtured by the development of oil painting and similar forms, hadn't established itself in Japan. It isn't apparent as we contemplate the

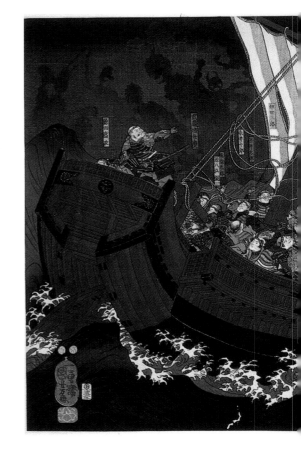

Katsushika Hokusai
*Pleasure Boats on the Sumida
River*, c. late 1830s
Colour woodblock

Utagawa Kuniyoshi
The Ghosts of the Heike,
c.1848–52
Colour woodblock

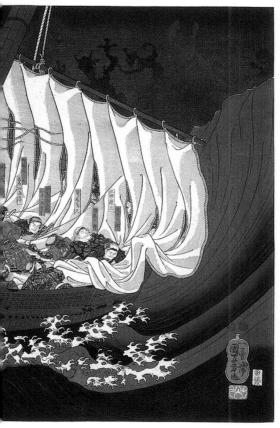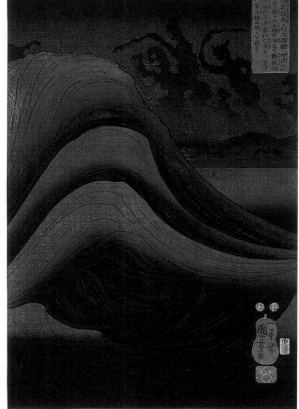

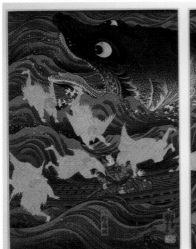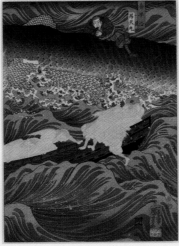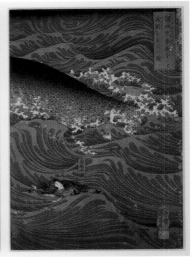

Utagawa Kuniyoshi, *Tametomo and his Son Rescued by the Tengu*, *c.*1848–52. Colour woodblock

skill of the cutting of wood, the printing and overprinting of colours or the subtleties of effect, that we are looking at one thing or the other; and there is no stigma attached to ink and paper and multiplicity.

TWO OTHER KINDS of craft are fundamental to Mark Twain's 1885 novel *The Adventures of Huckleberry Finn*: the riverboats that the author knew from his youth, and the raft on which Huck and Jim, the escaped slave, float down the surface of the great Mississippi. Probably it is this powerful aspect of the tale that has helped to make it so attractive to illustrators, and it has been many times revisited. Harry Brockway's illustrations for the Folio Society's 1993 edition of the novel are, like the Japanese prints, cut on wood – but to what different effect!

Wood engravings of this kind represent a twentieth-century revival of an old art and skill, with the conception and cutting directed immediately by the same hand. There is a consequent artistic intensity, even though the technique no longer answers to its original purpose of producing raised images that could be printed along with movable type. Brockway exploits the rich blackness to evoke the dark warmth of night, the power of the river, and the drama of the sudden appearance of the riverboat. Throughout the nineteenth century, however, wood engraving tools were overwhelmingly used by commercial craftsmen, to whom the creative artist's drawing was handed over. To compare the original and the printed version, as we are sometimes able to

do, often emphasises both the manipulative skill of the wood engravers and, nevertheless, the loss of subtlety entailed. But commercial wood engraving was not without its triumphs.

Harry Brockway
Huck and Jim on the Raft,
1992.
From Mark Twain, *The
Adventures of Huckleberry
Finn*, 1993
(The Folio Society, London)
Wood engraving

Harry Brockway
The Floating House, 1992.
From Mark Twain, *The
Adventures of Huckleberry
Finn*, 1993
(The Folio Society, London)
Wood engraving

Harry Brockway
The Storm, 1992. From
Mark Twain, *The
Adventures of
Huckleberry Finn*, 1993
(The Folio Society,
London)
Wood engraving

Harry Brockway
The Wreck of the Raft,
1992. From Mark Twain,
*The Adventures of
Huckleberry Finn*, 1993
(The Folio Society,
London)
Wood engraving

Gustave Doré's approach to illustration was heroic both in its mood and its prolific outpouring. Sometimes one has the sense that the artist was bent on illustrating every incident within a narrative, and more. Hence his illustrations for the *Contes Drôlatiques* and *Don Quixote*. Hence too his depictions of Samuel Taylor Coleridge's hallucinatory shipboard drama for an 1876 edition of *The Rime of the Ancient Mariner*. In these works the importance of the engraver was acknowledged, craftsmen and firms of craftsmen being mentioned by name; and though the scenario is all there in Doré's halftone originals, the full effect, I can't help feeling, only arrives in the engraver's performance. We see the artist's cloudy suggestions rendered with an astonishing range of technique which makes them precise and even more hallucinatory.

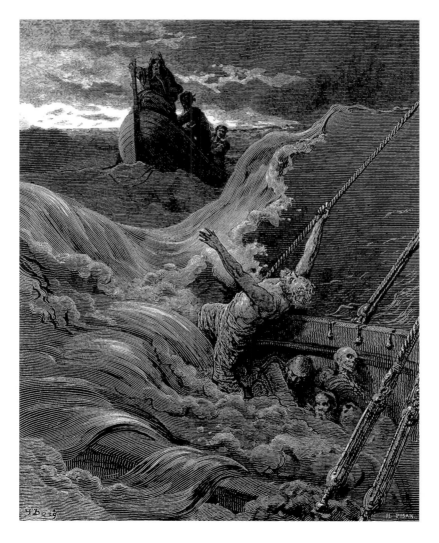

Gustave Doré
'Under the water it rumbled on, still louder and more dread.'
Illustration from Samuel Taylor Coleridge, *The Rime of the Ancient Mariner*, 1876 (Doré Gallery, London)
Wood engraving

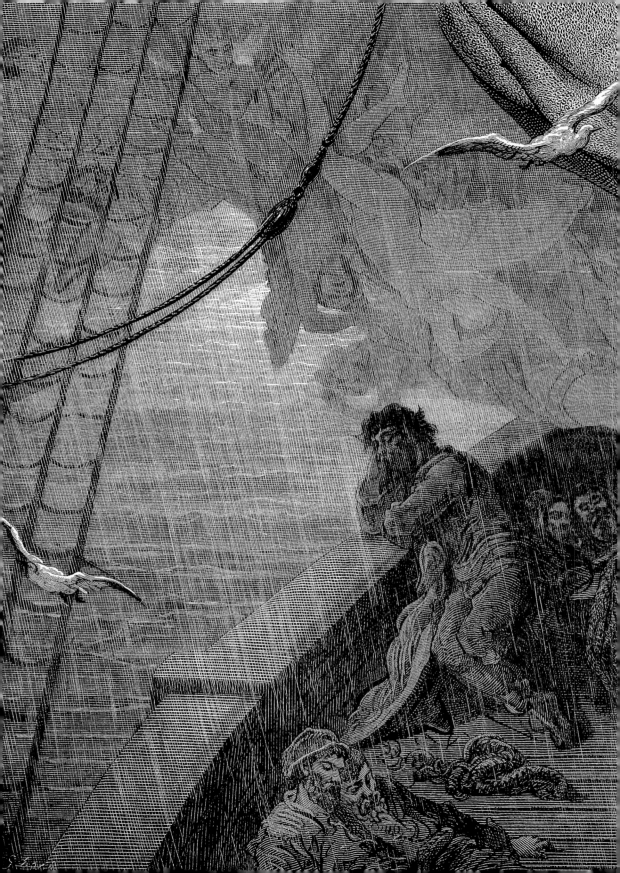

My own encounter with sailing craft was not the fruit of extensive travel, though it was the result of going regularly to the south-west of France. It was there that I was approached by a group of local teachers to find out if I would work with them, and with their junior school pupils, on a picture-storybook about contemporary humanitarian issues: war, racism, bullying, pollution. To start us off I made a few rough drawings of a representative boy and girl and – as I needed some kind of vehicle to get them from one scene of distress to another, and we were near the Atlantic coast – a small boat. To extend its possibilities, it was a boat that had wheels so that it could run on land, and was also, in some unexplained manner familiar to folktales, able to fly. These drawings went off to the classrooms where the children wrote, drew, made suggestions and advanced the story. Interestingly, everybody wanted the ship to fly – it rolled along a beach for take-off and after that flew on from place to place, never once dampening its keel. While the school contributions were being read and sorted out the project found itself going, via the internet, to other francophone schools – in London, Ireland, Luxemburg, Sweden and Singapore. The final work was brought together – ingredients in a soup would be a better comparison than patches in a quilt – with the involvement of 1,800 collaborators. One of the adult participants in the story made a point of opening out the conclusion so that young readers could be invited to think more about the implications, and not simply close the book as the story ended. It asks to be continued.

Quentin Blake, Original drawing for *Un Bateau dans le Ciel (A Sailing Boat in the Sky)*, 2000 (Rue du Monde, Voisins-Le-Bretonneux). Pen and watercolour

Gustave Doré, 'And the rain poured down from one black cloud.' Illustration from Samuel Taylor Coleridge, *The Rime of the Ancient Mariner*, 1876 (Doré Gallery, London). Wood engraving

26

Quentin Blake, Original drawing for *Un Bateau dans le Ciel (A Sailing Boat in the Sky)*, 2000 (Rue du Monde, Voisins-Le-Bretonneux). Pen and watercolour

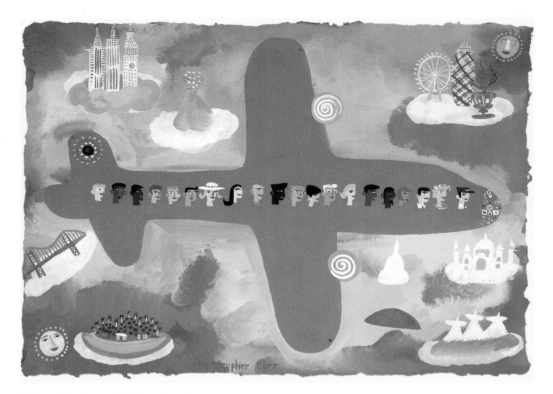

Christopher Corr, *Transworld Flight*, 2004. Gouache

If a mood of at least guarded optimism seemed appropriate to lighten the contemplation of the clutch of problems encountered by my sailing boat, the work of Christopher Corr seems to live in a world of comprehensive euphoria – summed up, perhaps, in the title of his London exhibition of 2004, *Big Car, New Haircut, Places to Go*. And Christopher Corr has certainly been to many places since he left the Royal College of Art in 1980 – North and South America, the Far East, Australia and the Pacific.

The work that he carried out for Qantas Airways in 1996 and 1997 overflows into his pictures of aeroplanes over cities. An apparent innocence holds hands with an aware sophistication – so that the simplification of a series of heads, as if seen through windows, is able to give us a sense of being suspended in space over our expected destination, a celebration of air travel without the delays.

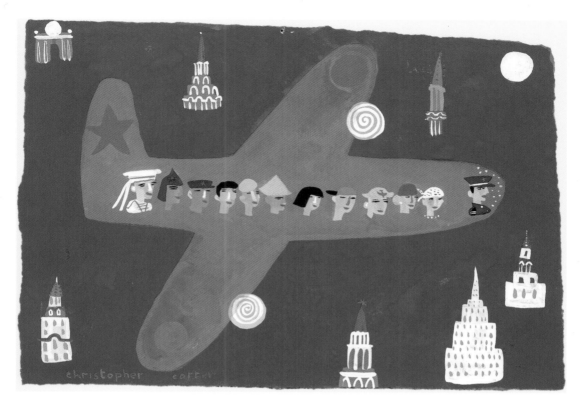

Christopher Corr, *Aeroflot flies over Russia*, 2000. Gouache

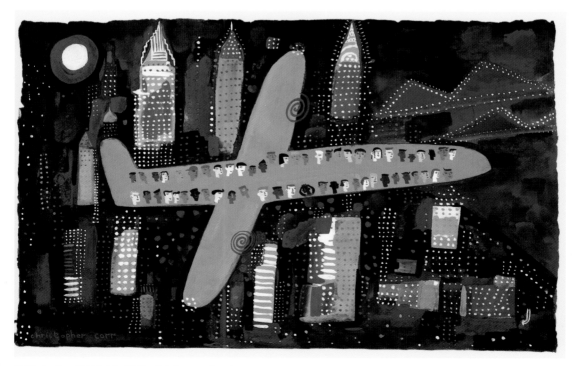

Christopher Corr, *Night flight to JFK, New York City*, 2002. Gouache

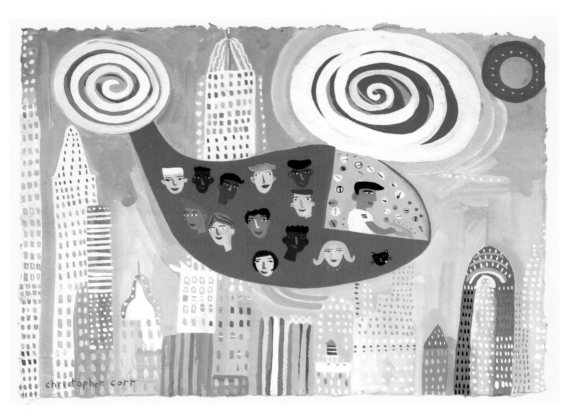

Christopher Corr, *Helicopter ride around New York City*, 2001. Gouache

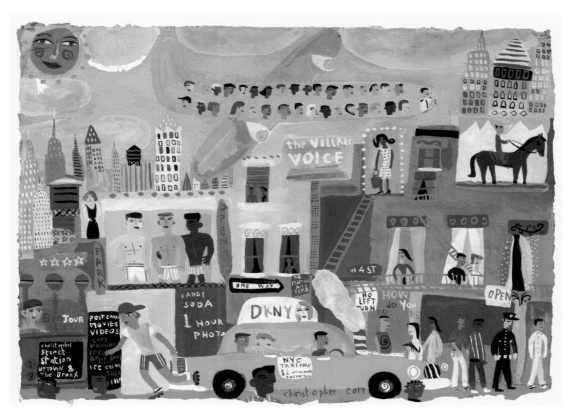

Christopher Corr, *Flying over Greenwich Village, NYC*, 2002. Gouache

If, as I hope, this collection of images offers a range and comparison of ways of travelling and the manners of its depiction, there is probably no comparison more diagrammatic among them than that between Linda Kitson's urgent notation of the Chinooks over South Georgia, Christopher Corr's transformation of a helicopter into an object of joy and entertainment, and Stephen Biesty's authoritative cross-section. Biesty gives in lucid form an amazing range of visual information – but part of his skill is that these machines are also inhabited. Life goes on in detail; if there is a shower there is certain to be someone in it, and if there is a loo there will be someone seated on it.

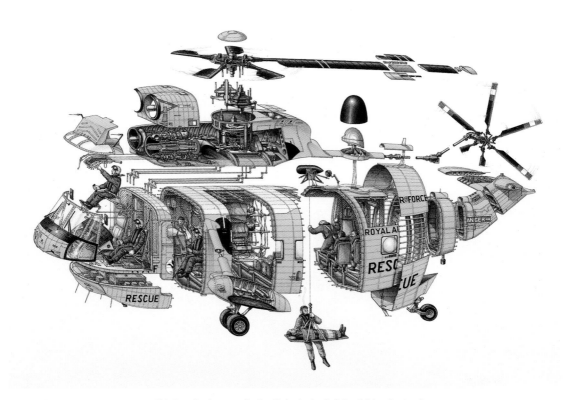

Stephen Biesty, *Helicopter*, 1990. For *Incredible Cross-Sections*, 1992 (Dorling Kindersley, London). Pencil, ink and watercolour

Stephen Biesty, *Space Shuttle*, 1990. For *Incredible Cross-Sections*, 1992 (Dorling Kindersley, London). Pencil, ink and watercolour

I F THE MOTORCAR doesn't feature in this modest excursion as much as it does in the contemporary consciousness, at least we are able to offer one small hint of the *élan* associated with its early days. Pierre Bonnard was a brilliant graphic artist as well as a great painter, and seemed to have an instinctive sense of the differences between the two modes. Line, diminished before colour in the paintings, carries everything in *LA 628-E8* (1908), Octave Mirbeau's journal of a car journey in northern France. The drawings, described as marginal sketches, look almost as though they were impromptus added to the printed text, and one is left slightly baffled by the idea that these marks can be at the same time so insouciant and so felicitous.

(above and right) **Pierre Bonnard**, Illustrations from Octave Mirbeau, *LA 628-E8*, 1908 (Librarie Charpentier et Fasquelle, Paris). Process prints after brush-drawings

OCTAVE MIRBEAU

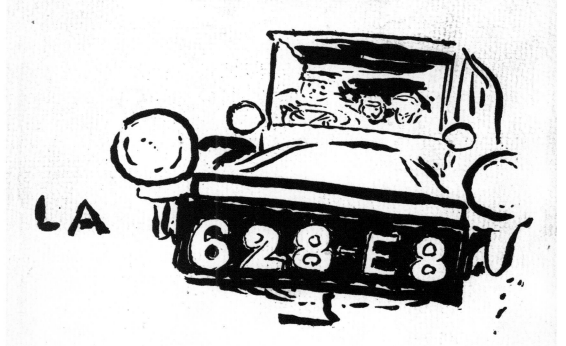

LA 628-E8

Croquis marginaux de
PIERRE BONNARD

Eugène FASQUELLE, Éditeur, Paris.

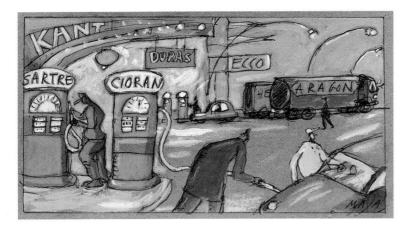

Daniel Maja
Station essence: Faites le plein
(At a petrol station: Filling up), 1998
Pen, watercolour, gouache, pastel and crayon

Another more recent French artist views the open road with a different eye. Daniel Maja draws for magazines – *Lire, Le Magazine Littéraire, The New Yorker* – where words and ideas are important, so that his vehicles are symbols or signals rather than reported fact. Nevertheless, they are not only that, and live in a parallel dream-world lit by its own nostalgic afternoon light.

So FAR I have tried to suggest in our travels some of the many forms that illustration can take. To attempt to define what, essentially, illustration is, is a more difficult exercise – but there is generally some sense of sequence, of narrative, of intimacy of scale – so that an illustration, even if enlarged to the size of a wall, still remains close to the gesture of the hand. But there have been plenty of artists happy to produce work in illustration alongside paintings, murals and other works, and

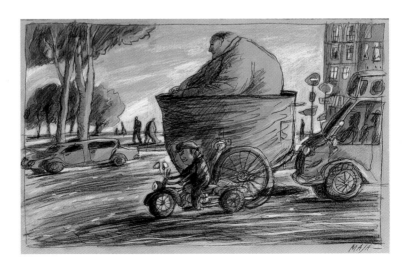

Daniel Maja
Large man in the sidecar of a
small motorcycle, 1997
Pen, watercolour, gouache,
pastel and crayon

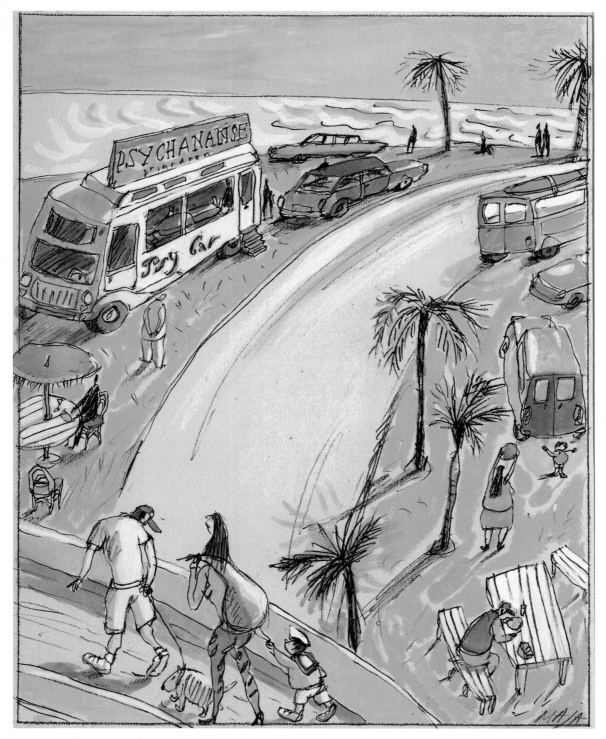

Daniel Maja, *A consommer sur place ou à emporter… (To eat on the spot or take away…)*, 2001. For *Bonheurs* (Glénat, Grenoble)
Pencil, ink, watercolour, gouache, pastel and crayon

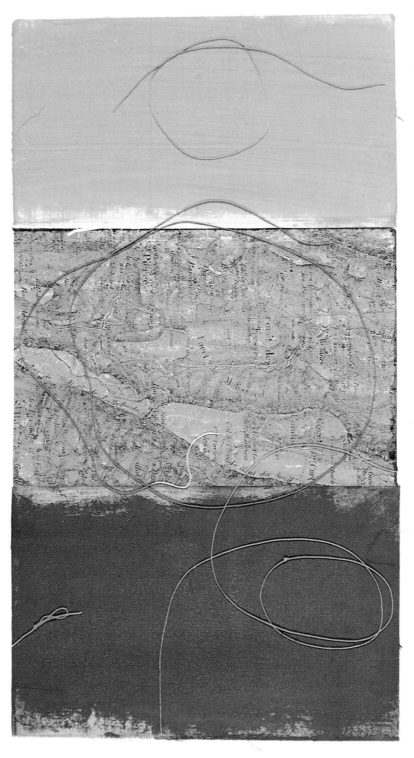

Dan Fern, *On the Road with Bashō*, 2004–05. Acrylic paint and painted threads on linen maps

indeed the strength of illustration is fed by a promiscuous visual appetite.

In the various roles of illustration, the relationship between image and text, narrative and situation may change and vary. Sometimes the pictures tell the story, *are* the story; or they are intimate with words; or perhaps they may be a parallel sequence, reflecting on the text as they run side by side, evoking atmosphere. Two examples that are not perhaps what first springs to mind as illustration are by Dan Fern, and Su Huntley and Donna Muir – though both of them relate unmistakably to the experience of travel.

Dan Fern is an illustrator and designer with a long experience of working with print, film and murals. He is also a mountaineer and hill walker. In *On the Road with Bashō* we do not even know his method of transport (though we can be pretty sure it's boots); it is an image that explores the borderlines of illustration and abstraction. Fern also writes poetry about places, and he senses an affinity with Bashō, the seventeenth-century master of the *haiku* – both travellers taken by precision and economy of form. Created on the backs of unfolded linen maps, with routes gestured at by painted threads, these works invite the relationship with text and the speculation about the journeys of our own personal maps.

Huntley and Muir work together on the same images, also in a mixture of media, and they have taken their distinctive approach beyond illustration into film, animation and stage design. What we have here, however, is a set of at first sight almost abstract photographs, approached not for their documentary detail, but in the same spirit that the artists bring to all the rest of their work. Huntley and Muir observed when these works were first shown: 'We've driven, drawn and photographed all over America and Europe … but for sheer sinister film noir beauty Shepherds Bush, Chiswick Roundabout, the M4, Reading Services really do it for us. But only at night.' Attracted by lights, the imagination enters the blackness of this special world and finds an evocative reality within the abstraction.

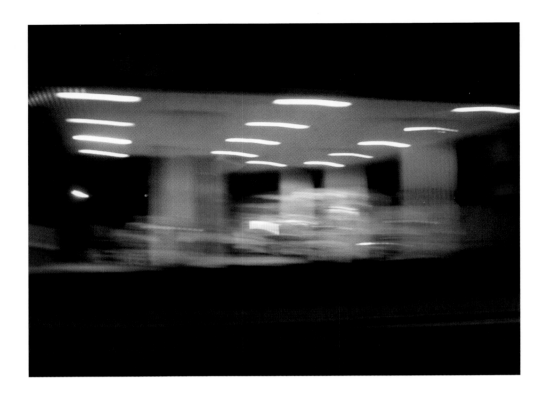

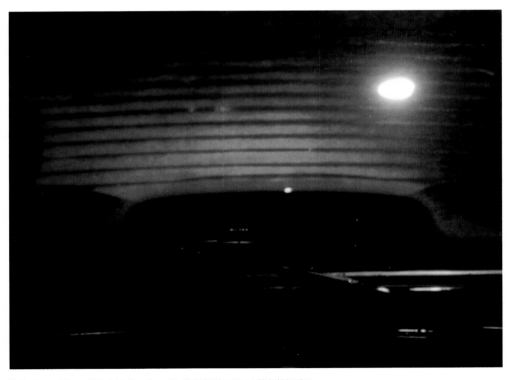

Su Huntley and Donna Muir, Prints from the series *Night Road*, 2002–04. Digital iris prints

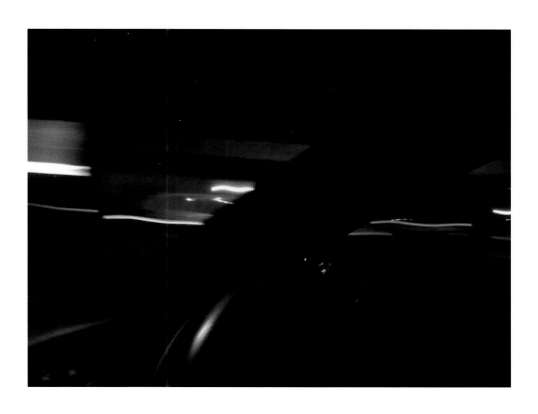

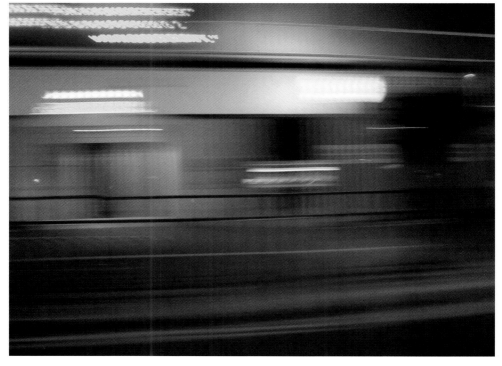

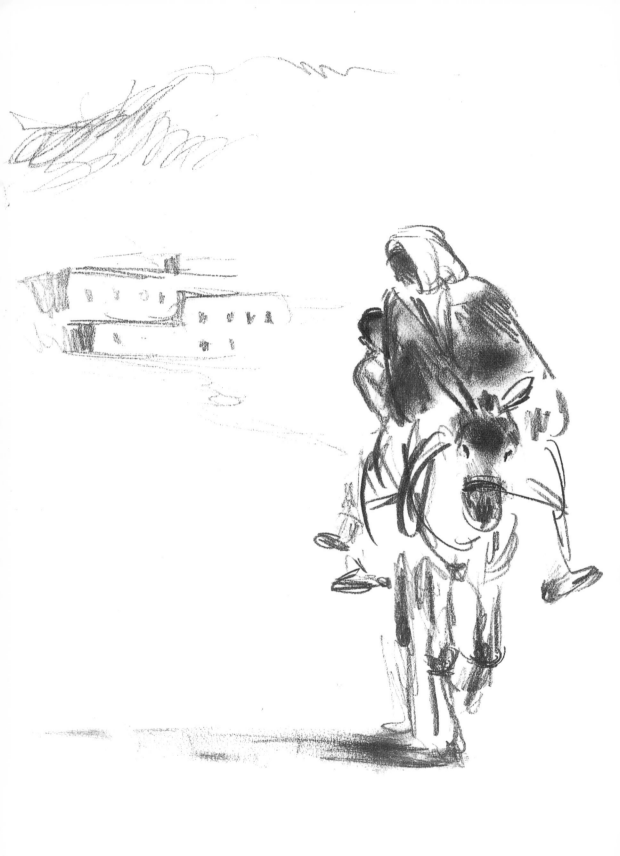

With or without maps and motorways, my instinct is to conclude this graphic outing as it began, on a donkey. Gabrielle Vincent is the publishing name (her children's books are famous) of the Belgian artist Monique Martin who died in 2000. *Nabil* is the title of her story of an Egyptian boy filled with a desire to see the Great Pyramid. He gets there partly on foot, partly by boat and partly on a donkey. There are few words – practically everything is told in pictures – lively drawings, simple in means, which look as though they were drawn from life. But can they have been? At least, thanks to sophisticated photo litho printing, we can sense the movement of the hand, we are close to the intimate act of drawing: and then, thanks also to process, the moment is there for all of us, over and over and over again, to be re-lived whenever we need it.

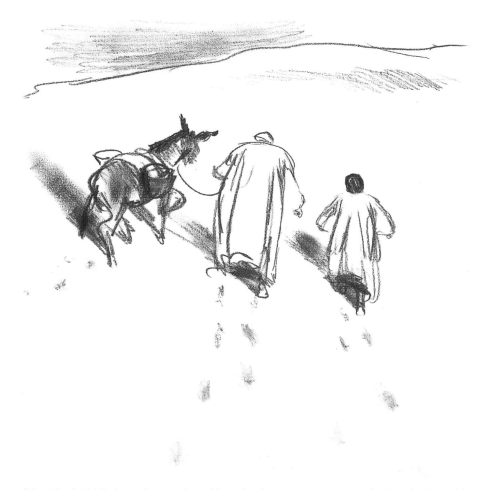

(left and above) **Gabrielle Vincent**, Illustrations from *Nabil*, 2000 (Rue du Monde, Voisins-Le-Bretonneux). Lithographs after pencil drawings

Glossary of Printmaking Terms Helen Luckett

Etching was developed in the early sixteenth century, and uses acid to eat lines into a metal plate. The plate is coated with an acid-resistant layer (called a 'ground') into which the artist draws a design with a stylus or needle, revealing the bare metal beneath. After being immersed in acid which bites into the exposed areas, creating the grooves that will hold the ink, the plate is covered with ink and the surface wiped clean, leaving ink in the incised lines or textures of the image. During printing, moistened paper is forced down into the inked areas of the plate, transferring the image onto the paper. Etching allows the artist great freedom of line, since drawing with an etching needle on the prepared ground is not very different from drawing with a pen on paper.

Lithography is a process that depends on the fact that grease and water do not mix. Invented in 1798, the method involves drawing an image with a waxy litho crayon or greasy liquid onto a specially prepared stone or metal plate which is then dampened with water. Oily printing ink rolled over the surface sticks to the drawing but is repelled by the damp area. The inked image is then transferred to paper by means of a high pressure press. Lithography faithfully records the artist's marks and gestures, however slight, from drawn lines and painted washes to splatterings of greasy liquid and fingerprints. In colour lithography, a separate stone or plate is used for each colour.

Photomechanical processes involve the transfer of an image to a printing matrix, such as an etching plate, relief block or a lithographic stone, by photographic means rather than by mechanical work carried out by the printmaker. The invention of photography in the nineteenth century revolutionised the technical processes of printmaking and by the 1880s there were many methods enabling a black line drawing to be transferred to a relief printing block (known as a **line-block**) photomechanically. **Half-tone printing** – a method of breaking up an image into dots of varying size by photographing it through a cross-lined screen, giving the illusion of a range of tones – and the **four-colour process** – in which a full range of colours is achieved by printing separate plates in cyan (turquoise blue), magenta (red), yellow and black dots – became the most successful means of commercial colour reproduction in the twentieth century.

74

Woodcut and **wood engraving** differ in that a woodcut is carved from a block of wood cut like a plank, with the grain running along its length, while wood engravings are carved from blocks of hard wood which has been cut across the grain, producing a more durable surface. Woodcuts first came into use in Europe in the fourteenth century. The texture and grain of the wood make fine lines or detailed effects difficult to achieve, but can be a feature in themselves. Developed in the eighteenth century, wood engraving produces more sophisticated effects and crisp, fine lines. Different types of burins – gravers, spitstickers, scorpers and tint tools – are used, producing distinct types of cuts. The engraving is not hindered by the direction of the grain and lines can flow freely in any direction. In eighteenth-century Japan, colour woodblock printing became a highly specialised craft, often involving ten or more separate blocks.

List of Works

All works are in centimetres, height x width x depth. Page references are to illustrations in this book. All works are on paper unless stated otherwise.

1 (p.34)
Anon
Akbar hawking on an elephant, c.1600–05
Opaque watercolour and gold
39.5 x 29.3 (sheet)
17.5 x 13.5 (image)
Victoria and Albert Museum
Photo: V&A Picture Library

2 (p.35)
(left panel) **Anon**; (right panel) **Tarh Basawan and Amal Chetar**
Akbar riding the elephant Hawa'i pursuing another elephant across a collapsing bridge, c.1590–95
Opaque watercolour and gold
Left panel: 37.5 x 23.9 (sheet);
34.5 x 22 (image); Right panel: 37.5 x 24 (sheet); 34.5 x 21.5 (image)
Victoria and Albert Museum
Photo: V&A Picture Library

3–6 (pp.20–23)
Edward Ardizzone (1900–79)
4 double page spreads from *Nicholas and the Fast-Moving Diesel*, 1948 (Eyre and Spottiswoode, London)
Lithographs
33 x 45.7 each
Courtesy of Quentin Blake
© The Estate of Edward Ardizzone 1948. Permission granted by the Artist's Estate
Photos: Mike Fear

7 (p.62)
Stephen Biesty (b. 1961)
Helicopter, 1990
For *Incredible Cross-Sections*, 1992 (Dorling Kindersley, London)
Pencil, ink and watercolour
45 x 63.4
Courtesy of the artist
© Dorling Kindersley Limited 1992
Photo: Mike Fear

8 (p.63)
Stephen Biesty (b. 1961)
Space Shuttle, 1990
For *Incredible Cross-Sections*, 1992 (Dorling Kindersley, London)
Pencil, ink and watercolour
67.5 x 49.6

Courtesy of the artist
© Dorling Kindersley Limited 1992
Photo: Mike Fear

9–13 (pp.55–57)
Quentin Blake (b. 1932)
5 original drawings for *Un Bateau dans le Ciel (A Sailing Boat in the Sky)*, 2000 (Rue du Monde, Voisins-Le-Bretonneux)
Pen and watercolour
38.2 x 56.5 each
Courtesy of the artist
© Quentin Blake 2000
Photo: Mike Fear

14 (pp.64–65)
Pierre Bonnard (1867–1947)
From Octave Mirbeau, *LA 628-E8*, 1908 (Librarie Charpentier et Fasquelle, Paris)
Book: process prints after brush drawings
24.7 x 20.8 x 4.5
Victoria and Albert Museum
© ADAGP, Paris and DACS, London 2005
Photos: V&A Picture Library

15
Pierre Bonnard (1867–1947)
From Octave Mirbeau, *LA 628-E8*, 1908 (Librarie Charpentier et Fasquelle, Paris)
Book: process prints after brush drawings
25 x 19.5 x 3.5
Courtesy Richard Nathanson Fine Art, London

16–19
Harry Brockway (b. 1958)
Huck and Jim on the Raft, 1992 (p.51)
26.5 x 19.2 (sheet); 9.3 x 7.5 (image)
The Floating House, 1992 (p.51)
26.5 x 19.2 (sheet); 10 x 7.4 (image)
The Storm, 1992 (p.52)
26.5 x 19.2 (sheet); 10 x 7.4 (image)
The Wreck of the Raft, 1992 (p.52)
26.5 x 19.2 (sheet); 10 x 7.4 (image)
From Mark Twain, *The Adventures of Huckleberry Finn*, 1993 (The Folio Society, London)
Wood engravings
Courtesy of the artist
Photos: Mike Fear

20–23
John Burningham (b. 1936)
4 original drawings for *Oi! Get Off Our Train*, 1989 (Jonathan Cape, London)
(p.26)

Pencil, ink, pastel and gouache on paper mounted on board; 39 x 52.7 (sheet); 31 x 43 (image)
(p.27)
Pencil, ink, pastel and gouache;
26.6 x 36.7 (sheet); 22.5 x 32.5 (image)
(pp.28–29)
Pencil, ink, pastel and gouache on paper mounted on board; 22 x 52.6
(p.29)
Pencil, ink, pastel and gouache on paper mounted on board; 26 x 30.8
Courtesy of the artist
Photos: Mike Fear

24 (p.59)
Christopher Corr (b. 1955)
Aeroflot flies over Russia, 2000
Gouache
19.7 x 28.4
Courtesy of the artist
Photo: Mike Fear

25 (p.60)
Christopher Corr (b. 1955)
Helicopter ride around New York City, 2001
Gouache
29.9 x 41.5
Courtesy of the artist
Photo: Mike Fear

26 (p.61)
Christopher Corr (b. 1955)
Flying over Greenwich Village, NYC, 2002
Gouache
30 x 41
Courtesy of the artist
Photo: Mike Fear

27 (p.59)
Christopher Corr (b. 1955)
Night flight to JFK, New York City, 2002
Gouache
36 x 58
Courtesy of the artist
Photo: Mike Fear

28 (p.58)
Christopher Corr (b. 1955)
Transworld Flight, 2004
Gouache
30 x 42
Courtesy of the artist
Photo: Mike Fear

29 (p.12)
George Cruikshank (1792–1878)
The Hobby Horse Dealer, 1819
Etching
25.2 x 35.4
Department of Prints & Drawings, The British Museum
Photo: © The Trustees of The British Museum

30 (p.13)
after **George Cruikshank**
R–L Hobby's!!!, 1819
Hand-coloured etching
24.4 x 34.8
Department of Prints & Drawings, The British Museum
Photo: © The Trustees of The British Museum

31 (p.17)
Honoré Daumier (1808–79)
'Allons donc… que diable cocher, votre coucou n'avance pas!…' (*'To hell with it, coachman, you are getting nowhere!…'*)
From the series *Les Chemins de Fer (The Railways)*, published in *Le Charivari*, 9 June 1843
Lithograph
26 x 38
Courtesy of Quentin Blake
Photo: Mike Fear

32 (p.17)
Honoré Daumier (1808–79)
Une diligence prise d'assaut (A coach taken by storm)
From the series *Les Chemins de Fer (The Railways)*, published in *Le Charivari*, 28 July 1843
Lithograph
25.9 x 36.7
Courtesy of Quentin Blake
Photo: Mike Fear

33 (p.19)
Honoré Daumier (1808–79)
Le danger de s'assoupir en voyage (The danger of dozing off during travel)
From the series *Les Chemins de Fer (The Railways)*, published in *Le Charivari*, 28 October 1843
Lithograph
25.2 x 33
Courtesy of Quentin Blake
Photo: Mike Fear

34 (p.19)
Honoré Daumier (1808–79)
'Comment il va y avoir des chemins de fer atmosphériques!…' (*'What do you mean, there are soon going to be air trains!…'*)
From the series *Les Chemins de Fer (The Railways)*, published in *Le Charivari*, 17 December 1843
Lithograph
24.2 x 31.7
Courtesy of Quentin Blake
Photo: Mike Fear

35 (p.18)
Honoré Daumier (1808–79)
'Vous cherchez votre malle, monsieur, elle est là!…' (*'You're looking for your trunk, Sir, there it is!…'*)
From the series *Les Chemins de Fer (The Railways)*, published in *Le Charivari*, 19 December 1843
Lithograph
26.4 x 34.2
Courtesy of Quentin Blake
Photo: Mike Fear

36 (pp.53–54)
Gustave Doré (1832–83)
From Samuel Taylor Coleridge, *The Rime of the Ancient Mariner*, 1876 (Doré Gallery, London)
Book: wood engravings
50.5 x 38.7 x 2.4
Victoria and Albert Museum
Photos: V&A Picture Library

37
Gustave Doré (1832–83)
From Samuel Coleridge, *The Rime of the Ancient Mariner*, 1877 (Harper & Brothers, New York)
Book: wood engravings
46.5 x 37 x 2.75
London Library

38
Dan Fern (b. 1945)
On the Road with Bashō, 2004–05
Acrylic paint and painted threads on linen maps
Diptych: 57 x 76 (sheet); 40.5 x 41 (overall image)
Courtesy of the artist

39
Dan Fern (b. 1945)
On the Road with Bashō, 2004–05
Acrylic paint and painted threads on linen maps
Diptych: 57 x 76 (sheet); 40.5 x 48.5 (overall image)
Courtesy of the artist

40
Dan Fern (b. 1945)
On the Road with Bashō, 2004–05
Acrylic paint and painted threads on linen maps
66 x 51 (sheet); 41.5 x 20 (image)
Courtesy of the artist

41 (p.68)
Dan Fern (b. 1945)
On the Road with Bashō, 2004–05
Acrylic paint and painted threads on linen maps
66 x 51 (sheet); 39 x 20 (image)
Courtesy of the artist

42–45
Michael Foreman (b. 1938)
4 original drawings for *The Little Ships*, 1997 (Pavilion Books, London)
(p.44)
42 x 59.4 (sheet); 20 x 37.5 (image)
(pp.44–45)
42 x 59.4 (sheet); 20 x 37.5 (image)
(p.45)
42 x 59.4 (sheet); 20 x 37.5 (image)
(pp.46–47)
42 x 59.4 (sheet); 20 x 52 (image)
Watercolours
Courtesy of the artist
Photos: Mike Fear

46 (p.30)
David Gentleman (b. 1930)
Hillgrove station on the Mettupalayam-Udagamandalam (Ooty) line, 1993
Pen and wash
26.5 x 36.5
Courtesy of the artist
Photo: Mike Fear

47 (p.31)
David Gentleman (b. 1930)
In the engine during the climb up Ooty: Stoking the fire, 1993
Pen and wash
18 x 27
Courtesy of the artist
Photo: Mike Fear

48 (p.31)
David Gentleman (b. 1930)
In the engine during the climb up Ooty: Taking a break, 1993
Pen and wash
18.2 x 27
Courtesy of the artist
Photo: Mike Fear

49 (p.32)
David Gentleman (b. 1930)
Manmad Junction station: Waiting for the Goa-Delhi train, 1993
Pen and wash
36.2 x 55.4
Courtesy of the artist
Photo: Mike Fear

50 (p.33)
David Gentleman (b. 1930)
Milly, Tabby and Tom on the Jaipur-Agra express, 1993
Pen and wash
31.1 x 27
Courtesy of the artist
Photo: Mike Fear

51 (p.32)
David Gentleman (b. 1930)
Second class carriage interior on the train to Udagamandalam (Ooty), 1993
Pen and wash
26.6 x 37
Courtesy of the artist
Photo: Mike Fear

52
Edward Gorey (1925–2000)
The Imprudent Excursion, 1962
For *Holiday*, May 1962
Pen and ink
40.5 x 29.2 (sheet); 32 x 23.2 (image)
The Edward Gorey Charitable Trust

53 (pp.24–25, reprints)
Edward Gorey (1925–2000)
31 original drawings for *The Willowdale Handcar or The Return of the Black Doll*, 1962 (The Bobbs-Merrill Company Inc., Indianapolis/New York)
Pen and ink
20.3 x 19.7 (each sheet); 7.6 x 10.8 (each image)
The Edward Gorey Charitable Trust
© The Edward Gorey Charitable Trust
Photos: courtesy Bloomsbury Publishing Plc, London

54 (p.14)
Hermann-Paul (René Georges Hermann-Paul, 1864–1940)
Biches au Bois (Frightened Animals)
From *Le Rire*, 8 December 1894
Lithograph
30.3 x 23.4
Courtesy of Quentin Blake

55 (p.48)
Utagawa Hiroshige (1797–1858)
Crossing the Yoroi Waterway, c.1837
Colour woodblock
23.8 x 36.5
Department of Asia: Japanese Antiquities, The British Museum
Photo: © The Trustees of The British Museum
(Only shown at Aberystwyth and Tullie House)

56
Katsushika Hokusai (1760–1849)
The Tonegawa River in Shimōsa Province, c.1830
Colour woodblock
17.1 x 25.7
Department of Asia: Japanese Antiquities, The British Museum
(Only shown at Aberystwyth and Tullie House)

57
Katsushika Hokusai (1760–1849)
Simplified View, Tago Beach [near] Ejiri on the Tōkaidō Highway, c.1830–33
Colour woodblock
25.2 x 36
Department of Asia: Japanese Antiquities, The British Museum
(Only shown at the Ferens, Worcester and Plymouth)

58 (p.49)
Katsushika Hokusai (1760–1849)
Pleasure Boats on the Sumida River, c. late 1830s
Colour woodblock
26 x 37.8
Department of Asia: Japanese Antiquities, The British Museum
Photo: © The Trustees of The British Museum
(Only shown at the Ferens, Worcester and Plymouth)

59–64 (pp.70–71)
Su Huntley (b. 1949) and **Donna Muir** (b. 1946)
6 prints from the series *Night Road*, 2002–04
Digital iris prints
46.5 x 60 each
Huntley Muir

65
Linda Kitson (b. 1945)
Air Crew and Trial Flight of Sea King 95, May 1982, 1982
Conté crayon
50.4 x 33
Imperial War Museum, London

66 (pp.38–39)
Linda Kitson (b. 1945)
Disembarking Troops to San Carlos Settlement, 2 June 1982, 1982
Conté crayon
25.3 x 35.5
Imperial War Museum, London
© Imperial War Museum, London

67 (p.37)
Linda Kitson (b. 1945)
Flight Deck Crew and Sea King 97, 16 May 1982, 1982
Conté crayon
50.3 x 33
Imperial War Museum, London
© Imperial War Museum, London

68 (p.36)
Linda Kitson (b. 1945)
Looking Down on the QE2 from a Sea King Helicopter – 'My first flight with 825 Squadron', May 1982, 1982
Conté crayon
29.7 x 21
Imperial War Museum, London
© Imperial War Museum, London

69 (p.40)
Linda Kitson (b. 1945)
Six hundred men a day go through 'Heli-training', 11 May 1982, 1982
Conté crayon
35.5 x 50.7
Imperial War Museum, London
© Imperial War Museum, London

70 (p.50)
Utagawa Kuniyoshi (1798–1861)
Tametomo and his Son Rescued by the Tengu, c.1848–52
Colour woodblock
Triptych, each sheet c.36.5 x 25
Department of Asia: Japanese Antiquities, The British Museum
Photo: © The Trustees of The British Museum
(Only shown at Aberystwyth and Tullie House)

71 (pp.48–49)
Utagawa Kuniyoshi (1798–1861)
The Ghosts of the Heike, c.1848–52
Colour woodblock
Triptych, each sheet c.36.5 x 25
Department of Asia: Japanese Antiquities, The British Museum
Photo: © The Trustees of The British Museum
(Only shown at the Ferens, Worcester and Plymouth)

72
Daniel Maja (b. 1942)
Two Men in a Boat, 1995
Pen, watercolour, gouache and pastel
21 x 30 (sheet); 10.8 x 19.1 (image)
Courtesy of the artist

73 (p.66)
Daniel Maja (b. 1942)
Large man in the sidecar of a small motorcycle, 1997
Pen, watercolour, gouache, pastel and crayon
32.5 x 49.8
Courtesy of the artist
Photo: Mike Fear

74 (p.66)
Daniel Maja (b. 1942)
Station essence: Faites le plein (At a petrol station: Filling up), 1998
Pen, watercolour, gouache, pastel and crayon
21 x 30 (sheet); 12.7 x 22 (image)
Courtesy of the artist
Photo: Mike Fear

75
Daniel Maja (b. 1942)
Spino for Ever, 1998
For *Le Magazine Littéraire*, No. 370, November 1998
Pencil, ink, watercolour, gouache and crayon
30 x 40 (sheet); 20.4 x 27.1 (image)
Courtesy of the artist

76 (p.67)
Daniel Maja (b. 1942)
A consommer sur place ou à emporter... (To eat on the spot or take away...), 2001
For *Bonheurs* (Glénat, Grenoble)
Pencil, ink, watercolour, gouache, pastel and crayon
40 x 30 (sheet); 27 x 20.2 (image)
Courtesy of the artist
Photo: Mike Fear

77 (p.15)
Lucien Métivet (1863–1937)
Au salon du cycle (At the cycling salon)
From *Le Rire*, 8 December 1894
Lithograph
30.3 x 23.4
Courtesy of Quentin Blake
Photo: Mike Fear

78 (p.16)
Lucien Métivet (1863–1937)
'Qu'il est triste, hélas! de s'entraîner toute seule!...' ('Alas, how sad it is! To travel all alone!...')
From *Le Rire*, 20 July 1895
Lithograph
30.3 x 23.4
Courtesy of Quentin Blake
Photo: Mike Fear

79
Georges Meunier (1869–1942)
Allégorie Pour Les Pauvres Bougres (Allegory of the Poor Devils)
From *Le Rire*, 15 June 1901
Lithograph
30.3 x 23.4
Courtesy of Quentin Blake

80–82
C.R.W. Nevinson (1889–1946)
Banking at 4,000 Feet (p.41)
40.6 x 30.4
In the Air
40 x 31.7
Swooping Down on a Taube
40 x 30.4
From the series *'Britain's Efforts and Ideals': Making Aircraft*, 1917
Lithographs
Imperial War Museum, London

83–90
Brian Robb (1913–79)
No. 7: A Rapid Disorganisation Group
16.4 x 26 (sheet); 14 x 18.6 (image)
No. 10: 173rd Extraordinary Diversion and Traffic Reduction Post (p.42)
16.1 x 27.2 (sheet); 13.5 x 18.5 (image)
No. 11: 5667251 Miscellaneous Accumulation Squadron
17 x 25.2 (sheet); 12.3 x 18 (image)
No 15: A Road-Making Equipment Abandonment Section
18.7 x 31.5 (sheet); 13.4 x 19.4 (image)
No. 19: 4/15 Desert Boring and Burrowing Section
17.2 x 26 (sheet); 11.5 x 17.6 (image)
No. 20: A Light Mobile Dumping Section in Action
15.2 x 26 (sheet); 12 x 17.3 (image)
No. 21: No. 3 Notice Board Painting and Maintenance Unit (p.43)
21 x 31 (sheet); 13 x 21.5 (image)
No. 22: No. 386 Road Obstruction Coy (p.43)
22.3 x 31.2 (sheet); 12.5 x 22 (image)
From the series *My Middle East Campaigns: Little-known Units of the Western Desert*, 1944
Pen and ink
Courtesy of Quentin Blake
Photos: Mike Fear

91–96
Giandomenico Tiepolo (1727–1804)
The Holy Family in a room with Joseph announcing the order to flee
18.6 x 24
Joseph leading the Virgin and Child through an archway (p.10)
18.3 x 23.9
The Holy Family walking beside the donkey (p.11)
18.8 x 24.6
The Holy Family embarking on a boat
18.3 x 24.2
The Holy Family being rowed by an angel in a boat (p.8)
17.5 x 23.6
The Virgin and Child with an angel, Joseph with the donkey (pp.6–7)
18 x 24.1
From the series *The Flight into Egypt*, 1753
Etchings
Department of Prints & Drawings, The British Museum
Photos: © The Trustees of The British Museum

97–99 (pp.72–73)
Gabrielle Vincent (1928–2000)
From *Nabil*, 2000 (Rue du Monde, Voisins-Le-Bretonneux)
Book: lithographs after pencil drawings
27.7 x 20.8
Three copies included in the exhibition

100
Charles Williams (active 1806–30)
Anti-Dandy Infantry Triumphant or the Velocipede Cavalry Unhobby'd, 1819
Hand-coloured etching
24.2 x 34.7
Department of Prints & Drawings, The British Museum

101 (p.13)
Charles Williams (active 1806–30)
The Parson's Hobby – or – Comfort for a Welch Curate, 1819
Hand-coloured etching
24.9 x 34.7
Department of Prints & Drawings, The British Museum
Photo: © The Trustees of The British Museum

Further Reading

Giovanni Domenico Tiepolo, Picturesque Ideas on the Flight into Egypt, Metropolitan Museum of Art, New York, 1972

Alderson, Brian, *Edward Ardizzone: A Bibliographical Commentary,* The British Library, London, 2003

Ardizzone, Edward, *Little Tim and the Brave Sea Captain,* Scholastic Press, London, 1999

Biesty, Stephen, *Incredible Cross-Sections,* Dorling Kindersley, London, 1992

Blake, Quentin, *Words and Pictures,* Jonathan Cape Ltd, London, 2000

Blake, Quentin, *A Sailing Boat in the Sky,* Jonathan Cape Ltd, London, 2002

Blake, Quentin, *Laureate's Progress,* Jonathan Cape Ltd, London, 2002

Borden, Louise, Foreman, Michael (Illustrator), *The Little Ships: The Heroic Rescue at Dunkirk in World War II,* Pavilion Books, London, 1997

Burningham, John, *Mr Gumpy's Outing,* Jonathan Cape Ltd, London, 1989

Burningham, John, *Oi! Get Off Our Train,* Jonathan Cape Ltd, London, 1989

Burningham, John, *The Magic Bed,* Jonathan Cape Ltd, London, 2003

Dickens, Charles, Cruikshank, George (Illustrator), *Sketches by Boz,* (1836), Wordsworth Editions Ltd, London, 1999

Dickens, Charles, Cruikshank, George (Illustrator), *Oliver Twist,* (1838), Penguin Books Ltd, London, 2002

Foreman, Michael, *War Game,* Puffin Books, London, 1995

Foreman, Michael, *War Boy: A Country Childhood,* Puffin Books, London, 2004

Gentleman, David, *David Gentleman's London,* Weidenfeld & Nicolson, London, 1985

Gentleman, David, *David Gentleman's India,* Hodder & Stoughton, London, 1995

Gentleman, David, *David Gentleman's Paris,* Weidenfeld & Nicolson, London, 2000

Gorey, Edward, *Amphigorey: Fifteen Books by Edward Gorey,* The Berkley Publishing Group, New York, 1972

Hillier, Jack Ronald, *The Art of Hokusai in Book Illustration,* University of California Press, Berkeley, California, 1980

Ingleby, Richard, *C.R.W. Nevinson: The Twentieth Century,* Merrell Publishers Ltd, London, 1999

Ives, Colta, *et al., Daumier Drawings,* Metropolitan Museum of Art, New York, 2000

Kitson, Linda, *The Falklands War: A Visual Diary,* Mitchell Beazley, London, 1982

Larkin, Oliver W., *Daumier. Man of His Time,* Beacon Press, Boston, 1968

Mirbeau, Octave, Bonnard, Pierre (Illustrator), *Sketches of a Journey: Travels in an Early Motorcar from Octave Mirbeau's Journal 'LA 628-E8',* Philip Wilson, London, 1989

Robb, Brian, *My Middle East Campaigns,* Collins, London, 1944

Ross, Clifford and Wilkin, Karen, *The World of Edward Gorey,* Harry N. Abrams Inc, New York, 1996

Terrasse, Antoine, *Pierre Bonnard, Illustrator: A Catalogue Raisonné,* Thames and Hudson, New York and London, 1989

White, Gabriel, *Edward Ardizzone,* The Bodley Head Ltd, London, 1979